LESSER SPOTTED BRITAIN
DOMINIC GREYER

PORTICO

First published in the United Kingdom in 2015 by
Portico
1 Gower Street
London
WC1E 6HD

An imprint of Pavilion Books Company Ltd

ISBN 978-1-90939-678-4

A CIP catalogue record for this book is available from the British Library.

10 9 8 7 6 5 4 3 2 1

Reproduction by Mission Productions Ltd, Hong Kong
Printed and bound by 1010 Printing International Ltd, China

This book can be ordered direct from the publisher at www.pavilionbooks.com

Foreword by Robert Popper

When I first met Dominic Greyer, he was wearing nothing but a pair of red underpants, while a lady in rubber gloves lobbed pieces of raw meat at him. No, this wasn't a South American jail, we were filming an episode of BBC's *Look Around You,* and Dominic had bravely (some might say stupidly) agreed to play the part of 'Nigel (Man in Pants)'. At that moment it was clear that Dominic was destined for greatness. Or a secure institution.

So, it was no surprise at all when a copy of *Lesser Spotted Britain* landed on my doormat one morning, bearing Dominic's name. For here was a man who had travelled literally thousands of miles up and down the country, just to point his camera at a road sign bearing the words 'Bully Hole Bottom'.

But where there's madness, there's genius, because *Lesser Spotted Britain* is not only laugh-out-loud funny, it's deeply poignant too. What lies beyond the land of Christmas Pie? And just what happens when the sun goes down in Needless Road?

Capturing the very essence of what makes Britain, well, Britain, each photograph is beautifully shot, and overflowing with wit – a unique blend of Ansel Adams and Monty Python.

I do hope you enjoy this book as much as I did. I'm off now to Assington to get myself a Cheese Bottom.

Robert Popper
Creator of *The Timewaster Letters* and *Friday Night Dinner*

LOGIN <small>CARMARTHENSHIRE, WALES</small>
Etymology 'Little polluted river'.
Location Situated at the confluence of the River Taf and its tributary Afon Wenallt near the border with Pembrokeshire and close to Cwm Miles, Crosshands and Glandy Cross.

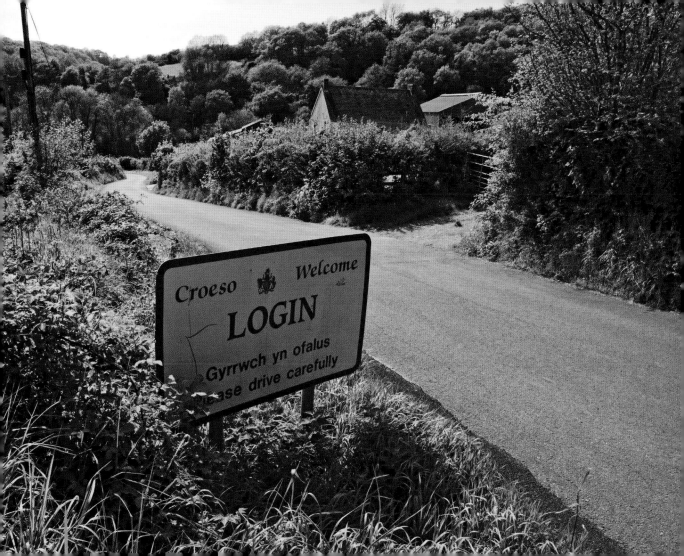

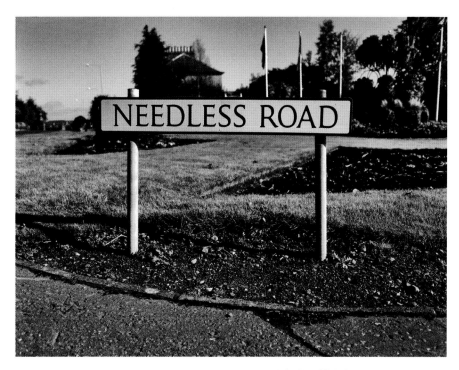

NEEDLESS ROAD PERTH, SCOTLAND

Etymology If this were a dead-end lane it would make sense, but it's not – see below.
Location Despite its rather disparaging name, Needless Road provides a direct link between the A93 Glasgow Road and Glover Street, so it's handy for Perth train station.

ASSINGTON SUFFOLK, ENGLAND

Etymology Farm belonging to a man called Assa, which would appear to mean 'ass' with reference to donkeys.
Location Off the A134 near Hagmore Green, Sackers Green and Workhouse Green.

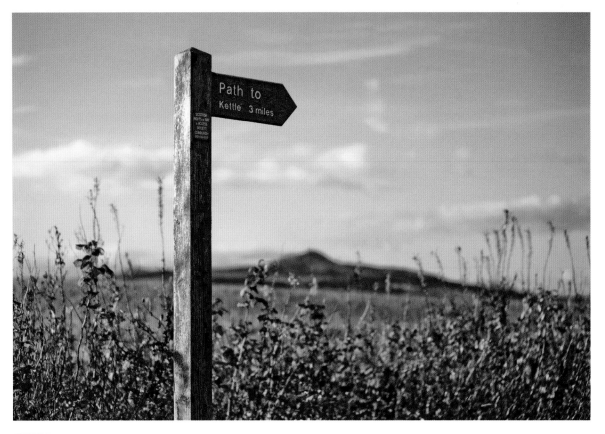

KETTLE FIFE, SCOTLAND
Etymology Pictish *catt-el*, meaning 'cat-place, place where wild cats live'.
Location Turn off the A914 Cupar Road onto the B9129 between Balmalcolm and Kettlebridge, home to the Kettle Bowling Club, which conjures up a lovely surreal image.

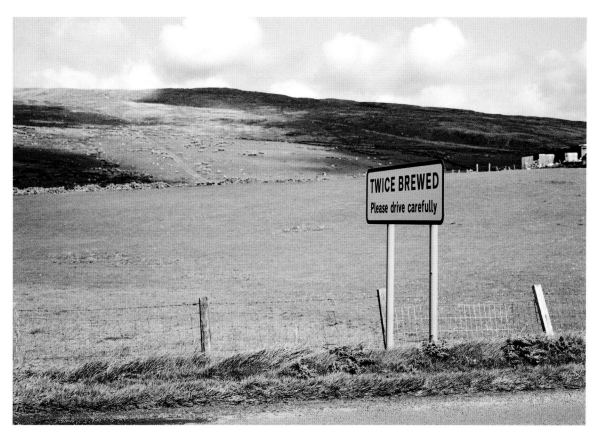

TWICE BREWED NORTHUMBERLAND, ENGLAND
Etymology An inn name for which there are folk aetiologies (King Charles asking
if they would brew the ale again as it was so good).
Location On the B6318, also known as the Military Road after the 1745 Jacobite rebellion necessitated
the building of a new road to transport troops; partly constructed from nearby Hadrian's Wall.

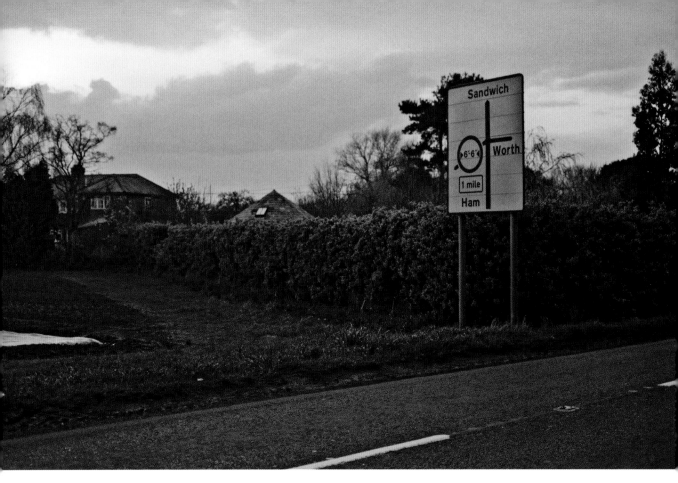

HAM and SANDWICH KENT, ENGLAND
Etymology Old English *hamm*, 'land hemmed in (by water)'; 'sandy harbour',
Old English *sand*, with *wic*, 'harbour or depot'.
Location Ham is equidistant between Updown and Worth; if approaching Sandwich from Shatterling, carry on
along the A257 through Each End. Sandwich is home to the fabulously named Sir Roger Manwood's School.

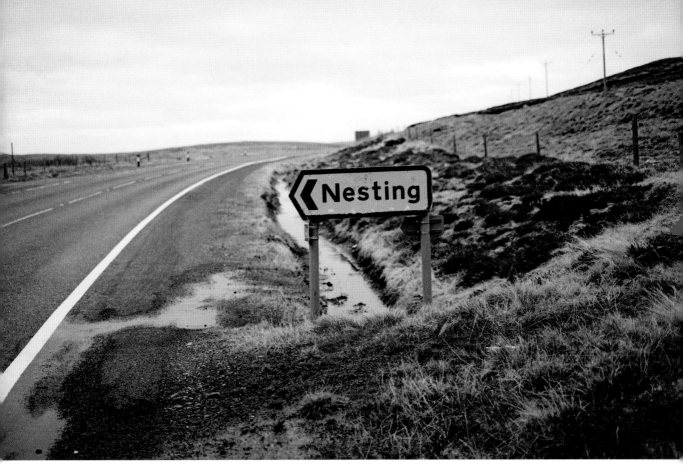

NESTING SHETLAND, SCOTLAND
Etymology A Scandinavian name meaning 'promontory where the local council meets': *nes*, 'promontory', with *thing*, 'local council, meeting'.
Location Situated on the east side of Mainland, ten miles north of Lerwick.

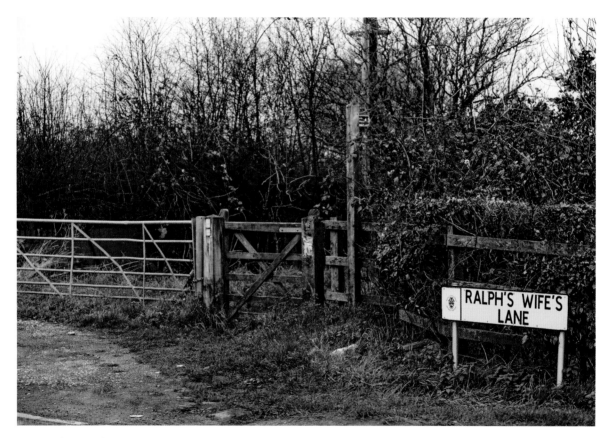

RALPH'S WIFE'S LANE BANKS, LANCASHIRE, ENGLAND
Etymology From an old folk tale about the ghost of a widowed fisherman who was lost at sea.
Location Runs between Crossens and Banks.

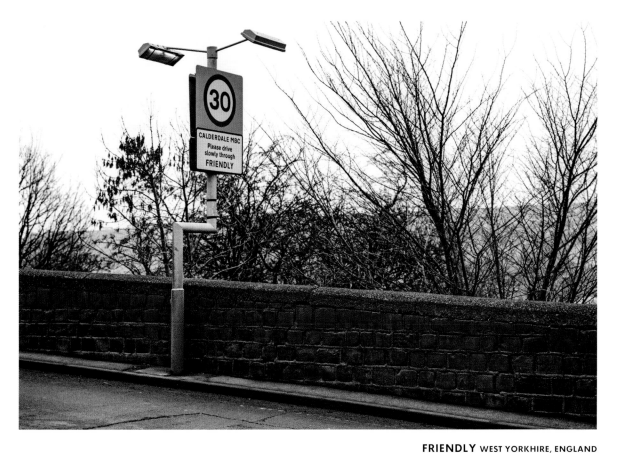

FRIENDLY WEST YORKHIRE, ENGLAND
Etymology Possibly named after the local hostelry, The Friendly Inn.
Location On the A646 between Halifax and Mytholmroyd.

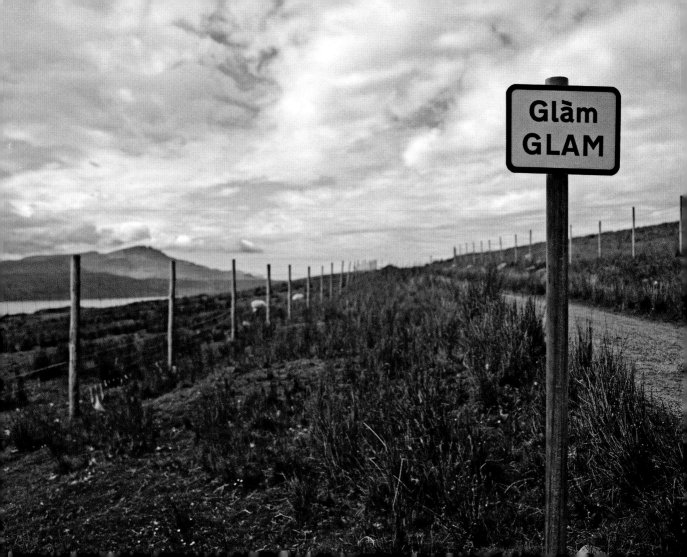

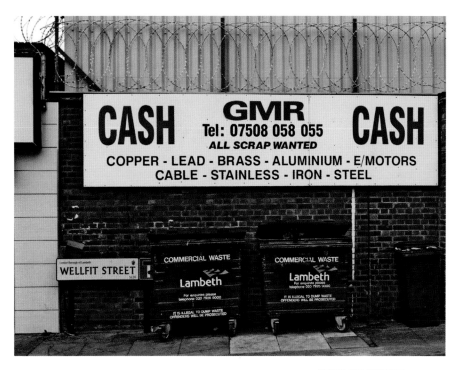

WELLFIT STREET LAMBETH
Etymology Either a surname or nickname meaning 'well fed' (see also Glutton Bridge),
or a reference to Welford (most likely the one in Berkshire).
Location A dead end that is far from fit – it's off the B222 at Hinton Road near Loughborough Junction.

GLAM ISLE OF RAASAY, HIGHLAND, SCOTLAND
Etymology Possibly Scots *glam*, 'boggy'.
Location Take the only road north and it's about four miles before the ruins of Brochel Castle. It offers
stunning views over the Sound of Raasay to the Trotternish Ridge on the Isle of Skye.

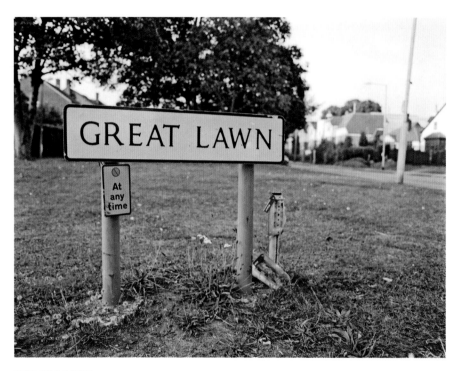

GREAT LAWN ONGAR, ESSEX, ENGLAND
Etymology The earliest spellings show the name to be the surname *Lane*, so 'the larger piece of land belonging to the Lane family'.
Location A dead end off the B184, a stone's throw from Great Stony Park.

CRACKINGTON HAVEN CORNWALL, ENGLAND
Etymology 'Harbour at a farm called Crak'. *Crak* is Cornish for a rock outcrop.
Location Take a lane off the B3263 and go past Sweets before descending down to sea level.

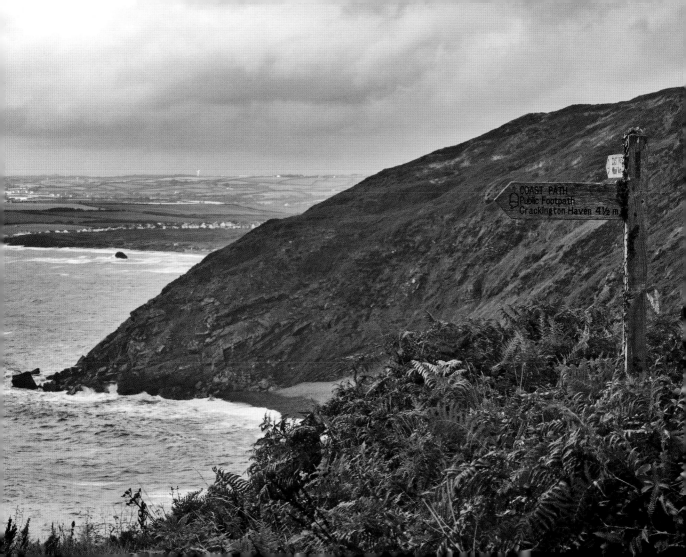

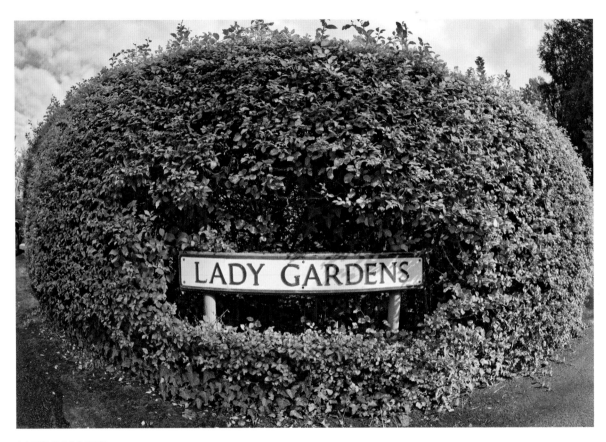

LADY GARDENS EARDISLEY, HEREFORDSHIRE
Etymology Most likely a reference to the Virgin Mary, 'Our Lady'.
Location A quiet cul-de-sac off the A4111 on the way into Eardisley.

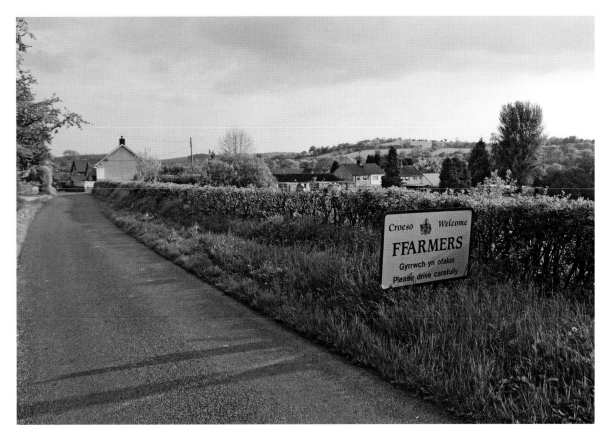

FFARMERS CARMARTHENSHIRE, WALES
Etymology Named after the nearby hostelry, The Farmer's Arms.
Location Turn off the A482 onto Sarn Helen – it's about two miles along the road.

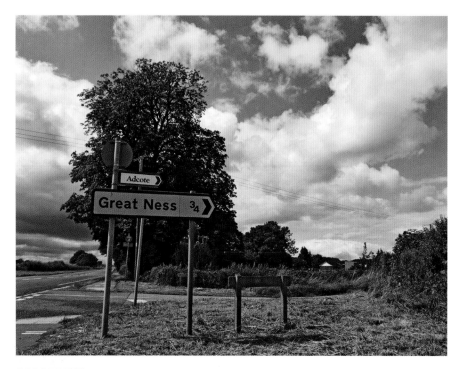

GREAT NESS SHROPSHIRE, ENGLAND
Etymology From the Old English *naess* meaning 'promontory or projecting ridge'.
Location An estate agent might describe Great Ness as being 'moments from the ever-popular A5', but I prefer to say it's near to Little Ness and Nib Heath.

GOLDEN BUTTS ROAD ILKLEY, WEST YORKSHIRE, ENGLAND
Etymology 'Golden' usually refers to flowers of yellow colour; this would be 'irregular-shaped pieces of land at the end of a field growing with golden flowers'.
Location Runs between Little Lane and Railway Road and is home to the Golden Butts Recycling Centre and Household Waste Site.

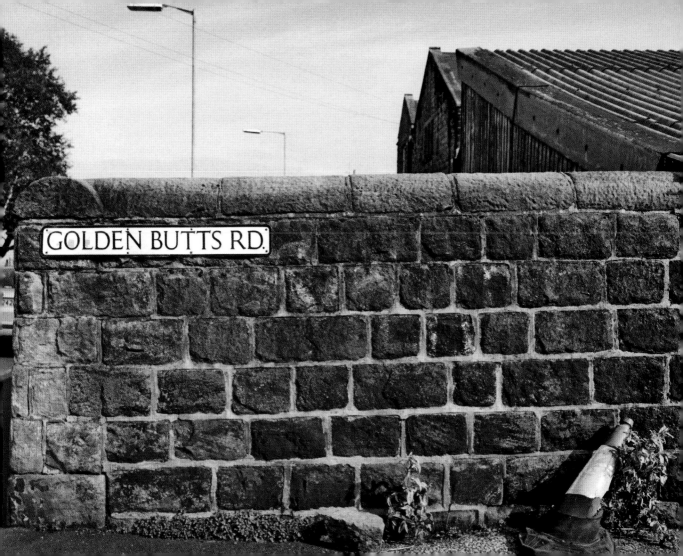

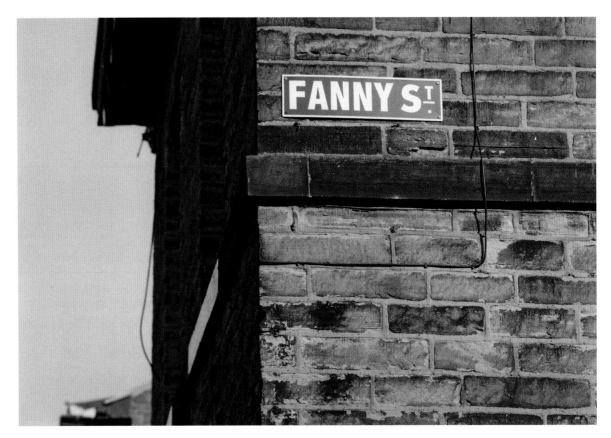

FANNY STREET SALTAIRE, WEST YORKSHIRE, ENGLAND
Etymology Fanny was a daughter of Sir Titus Salt, the millowner who founded Saltaire in 1851.
Location Take Albert Road from the roundabout on the A650 Bingley Road, turn right along Carlton
Avenue and then left down Mary Street – this will lead you into Fanny Street.

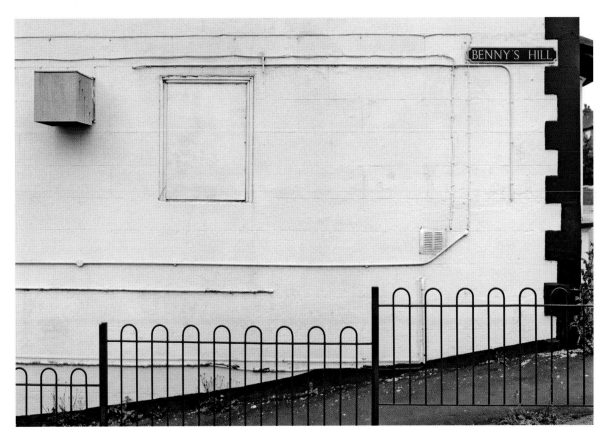

BENNY'S HILL KEGWORTH, LEICESTERSHIRE, ENGLAND
Etymology This could be 'hill growing with bent grass', but perhaps more likely Benny is a surname.
Location The latter etymology is more likely, as this is merely a lane that runs along the side of the Diamond City Chinese takeaway – the self-proclaimed longest-serving takeaway in Kegworth.

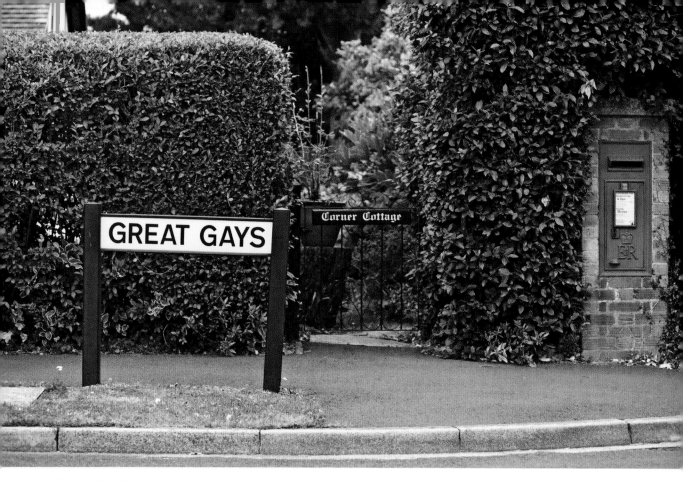

GREAT GAYS STUBBINGTON, HAMPSHIRE, ENGLAND
Etymology Probably 'the larger field belonging to a family called Gay'.
Location Between Haven Crescent and Old Street, just around the corner from Little Gays.

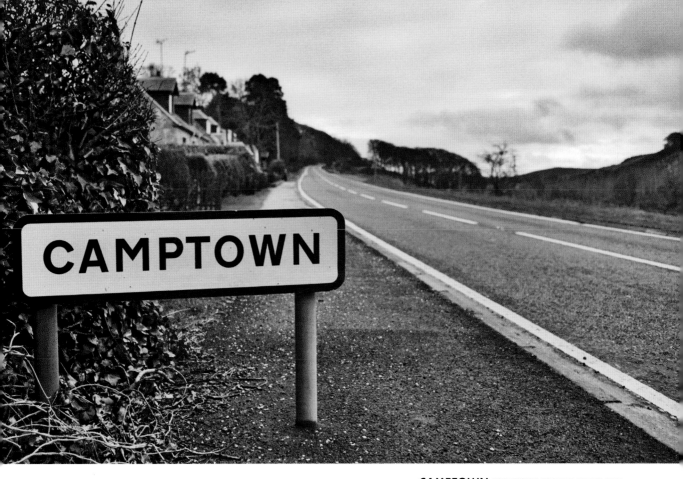

CAMPTOWN SCOTTISH BORDERS, SCOTLAND
Etymology Possibly 'settlement at a battle-site'.
Location On the A68 five miles south of Jedburgh, near Old Jedward and Lawsuit Law.

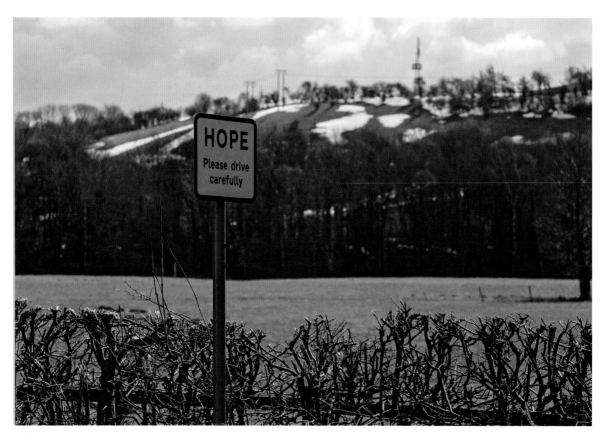

HOPE DERBYSHIRE, ENGLAND
Etymology Old English *hop*, 'a remote valley'.
Location Situated between Castleton and Brough in the Peak District National Park.

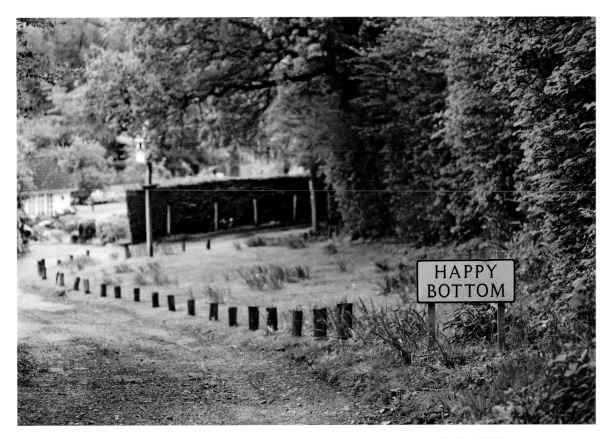

HAPPY BOTTOM DORSET, ENGLAND
Etymology 'Bottom' is Old English *bothm*, 'valley bottom': low-lying land, often with a stream;
'happy' is likely to reflect the productivity of the land.
Location At the end of a quiet lane in Corfe Mullen – the residents of which are hoping it will remain that way.

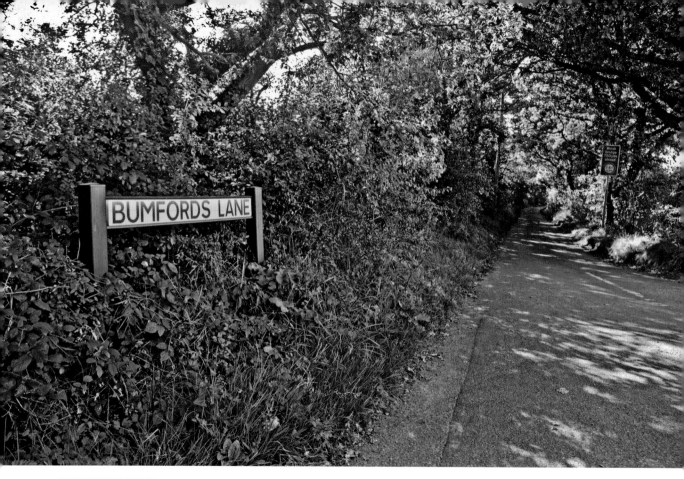

BUMFORDS LANE ULTING, ESSEX, ENGLAND
Etymology the earliest spelling is *Bongefford* (1285): *bong* is a variant form of 'bank', so the name probably means 'river-crossing by a bank'.
Location A long country lane running between Crouchman's Farm Road and Mowden Hall Lane.

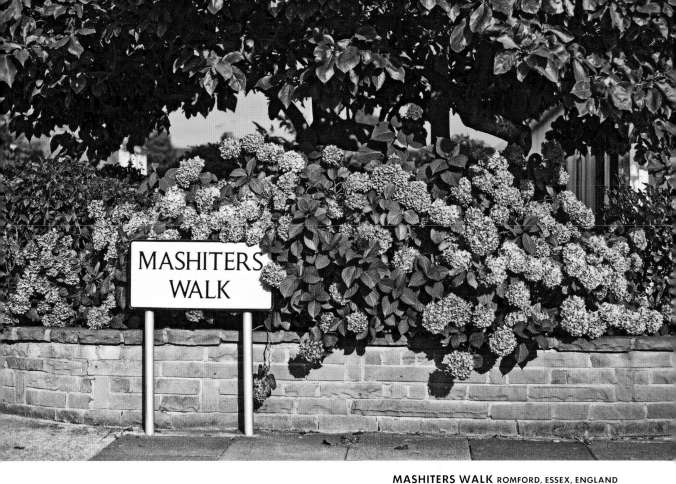

MASHITERS WALK ROMFORD, ESSEX, ENGLAND
Etymology The Mashiter family is recorded here from 1876.
Location A crescent-shaped road with an elongated section leading to Marshalls Drive.

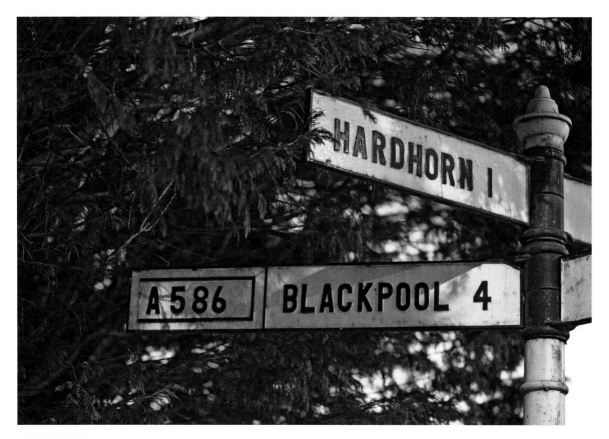

HARDHORN LANCASHIRE, ENGLAND
Etymology 'Store-house': Old English *hord*, 'store' with *aern*, 'house, barn'.
Location Heading into Blackpool on the B5266, go through Singleton and take a right towards Poulton-le-Fylde.

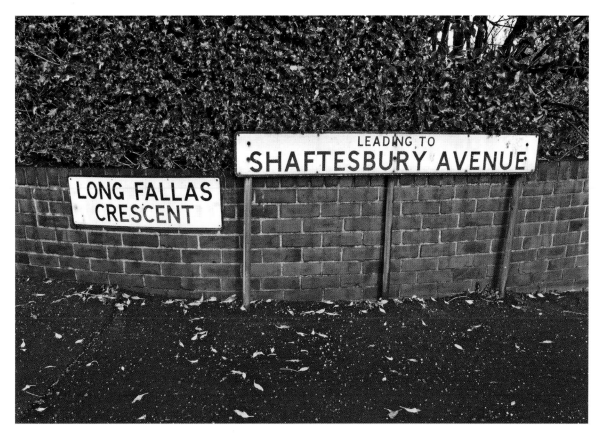

LONG FALLAS CRESCENT BRIGHOUSE, WEST YORKSHIRE, ENGLAND
Etymology Possibly from Old English *fealh*, 'fallow land', so 'crescent built on or near long strips of ploughed or fallow land'.
Location More a dogleg than a crescent, running between Woodhouse Lane and Somerset Avenue.

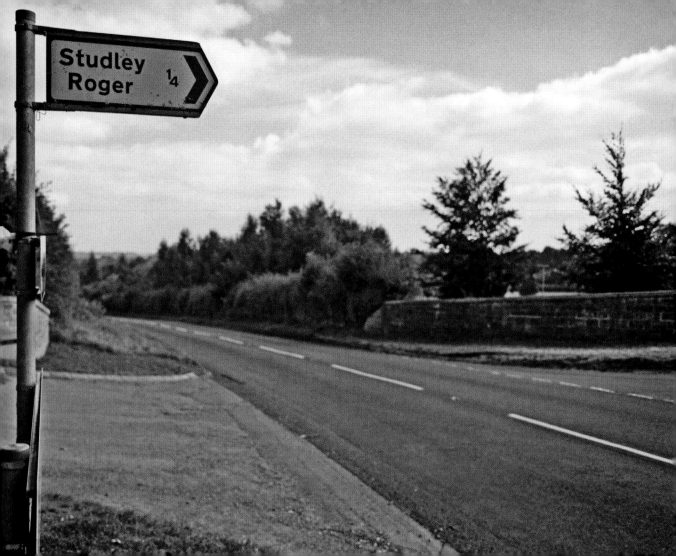

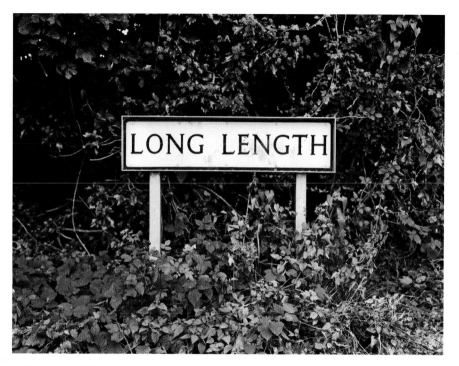

LONG LENGTH KINGSNORTH, KENT, ENGLAND
Etymology Possibly a reference to a feature unusually long.
Location Runs between Chart Road and Magpie Hall Road on the outskirts of Ashford.

STUDLEY ROGER NORTH YORKSHIRE, ENGLAND
Etymology Old English *stod*, 'a herd or stud of horses' with *leah*, 'a clearing in woodland'; the name Roger is recorded from the 13th century and may have been a local lord or church dignitary.
Location Turn into Studley Lane from the B6265; the village is a third of a mile away. Just beyond the village is UNESCO world heritage site Studley Park, which contains the ruins of Fountains Abbey.

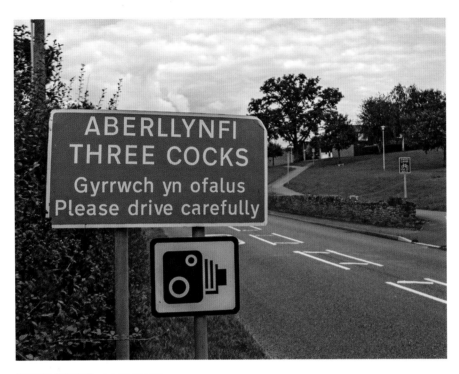

THREE COCKS POWYS, WALES
Etymology Three cocks appeared on the arms of the local Williams family of Gwernyfed.
Location At the junction of the A4079 and A438 between Glasbury, Bronllys and Boxbush.

DREGHORN EAST AYRSHIRE
Etymology 'Dry house', from Old English *dryge*, 'dry', and *ærn*, 'a house or building often used for storage'.
Location Almost equidistant between Irvine and Kilmarnock on the B7081.

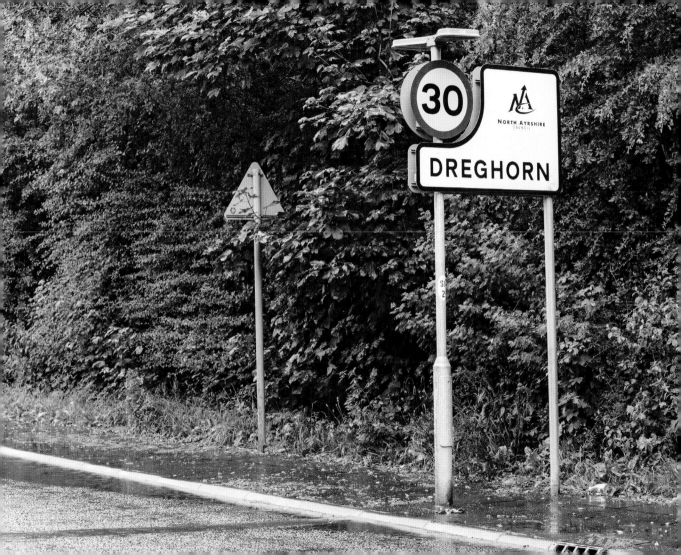

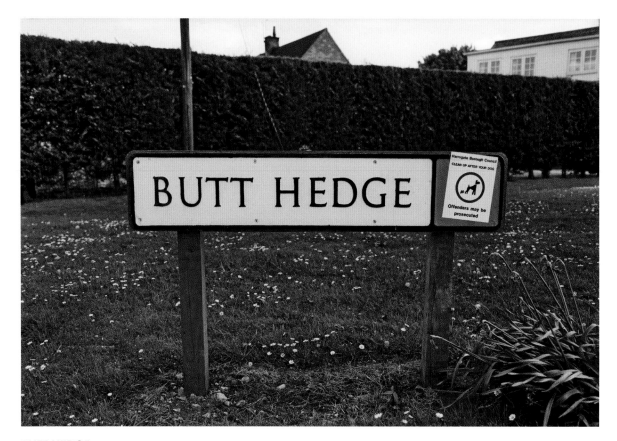

BUTT HEDGE LONG MARSTON, NORTH YORKSHIRE, ENGLAND
Etymology A *butt* in Middle English is either an irregular piece of land at the end of arable strips, or a place for practising archery. The first is likely here: 'an irregular piece of land with a hedge'.
Location A cul-de-sac off Angram road near the junction with the B1224.

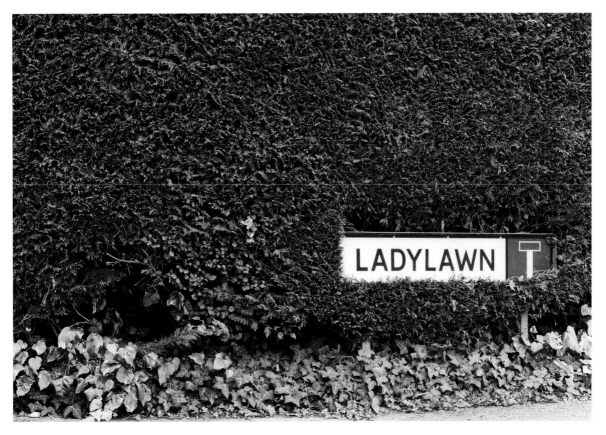

LADYLAWN TRULL, SOMERSET, ENGLAND
Etymology Probably 'woodland pasture (Old French *launde*) dedicated to the Virgin Mary',
but the lady could refer to a local lady.
Location A cul-de-sac off Wild Oak Lane.

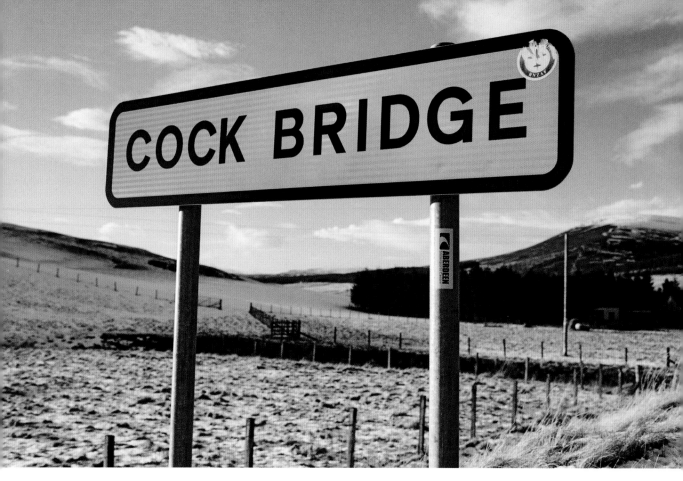

COCK BRIDGE ABERDEENSHIRE, SCOTLAND
Etymology Probably a water-crossing used by birds in general, or, more specifically, woodcock.
Location In the Cairngorms on the A939 only 10 miles from Lost, home to the fantastically named Allargue Arms, if deliberately mispronounced.

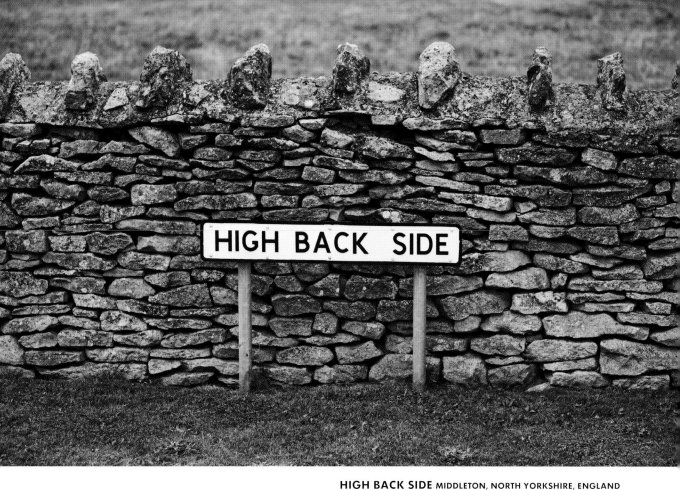

HIGH BACK SIDE MIDDLETON, NORTH YORKSHIRE, ENGLAND
Etymology 'High hillside at the back of the houses/road/settlement'.
Location Upon entering Middleton on the A170 from Pickering, take the first right.

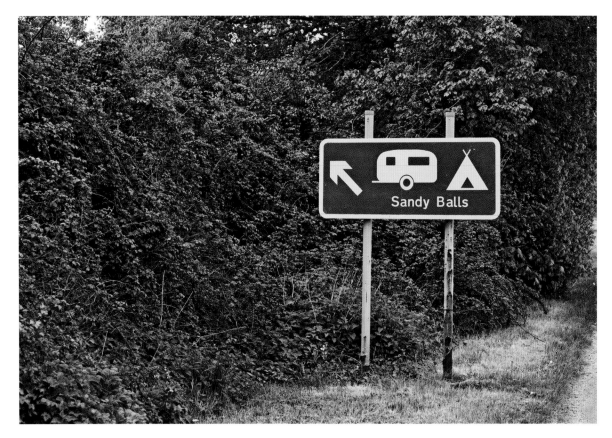

SANDY BALLS HAMPSHIRE, ENGLAND
Etymology In this case, *ball* means 'mound set up as a marker, possibly of a boundary', so sandy balls are marker-mounds of sand.
Location On the northwest edge of the New Forest on the B3078 Roger Penny Way.

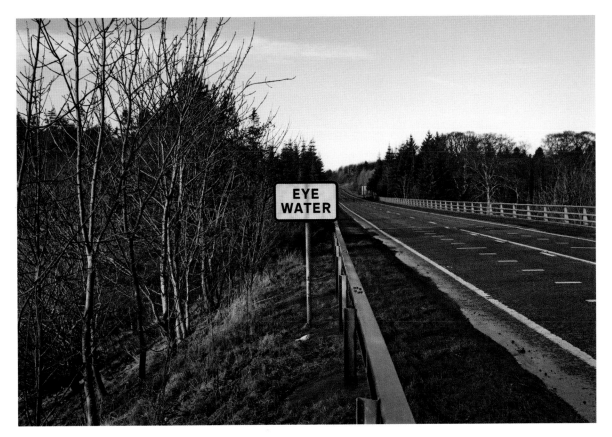

EYE WATER BORDERS, SCOTLAND
Etymology Old English *ea*, 'a river, a stream', with *waeter*, 'a lake, a pool.'
Location The source of Eye Water is on Wester Dod in the Lammermuir Hills – it runs roughly 20 miles to the North Sea at Eyemouth.

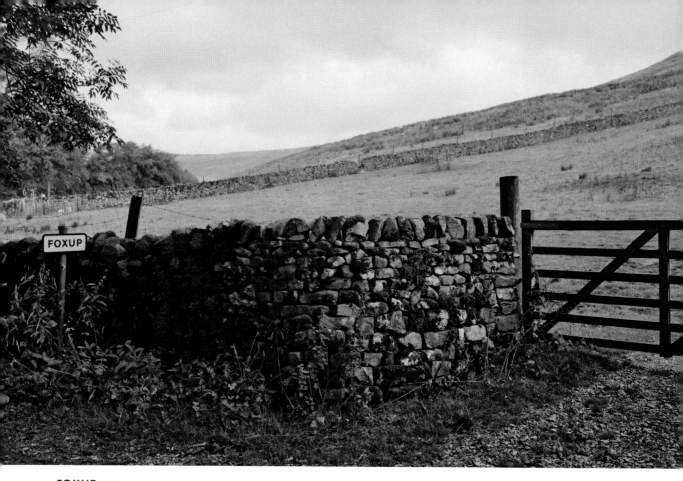

FOXUP NORTH YORKSHIRE, ENGLAND
Etymology Probably 'fox valley', Old English *fox* with *hop*, 'a remote or enclosed valley'.
Location Just after the confluence of Cosh Beck and Foxup Beck at the head of Littondale.

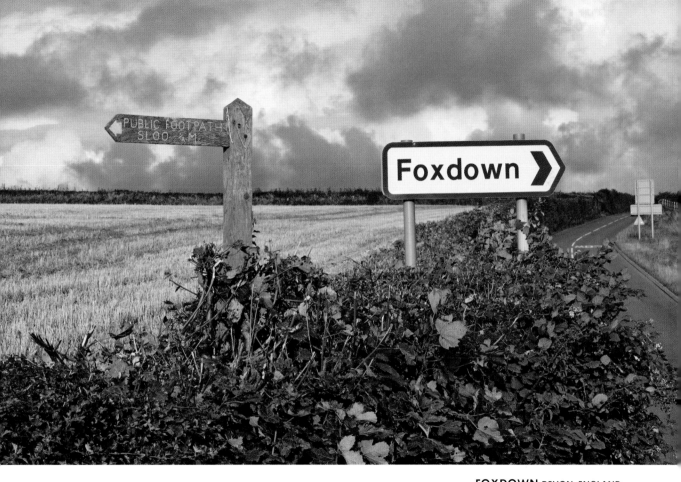

FOXDOWN DEVON, ENGLAND
Etymology 'Fox hill'.
Location A couple of minutes from the A39 on the banks of the River Yeo, near Sloo and not too far from Horns Cross.

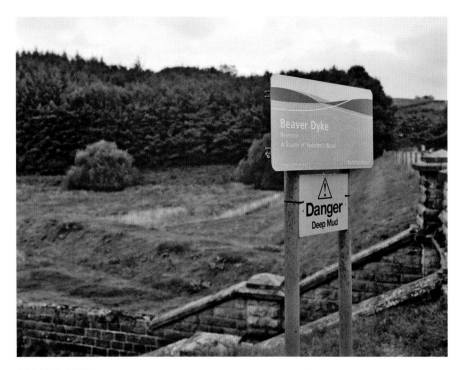

BEAVER DYKE NORTH YORKSHIRE, ENGLAND
Etymology Possibly 'bank resembling a beaver dam': Old Norse *dík*, 'a bank or ditch'.
Location A drained reservoir almost equidistant between Kettlesing Bottom and Bland Hill – a scenic hike only 20 minutes from Penny Pot Lane.

BUNNY NOTTINGHAMSHIRE, ENGLAND
Etymology 'Dry, raised ground in a marsh growing with reeds': Old English *bune*, 'reed', with *eg*, 'island, dry ground in marsh'.
Location On the A60 north to Ruddington, about three miles from Gotham.

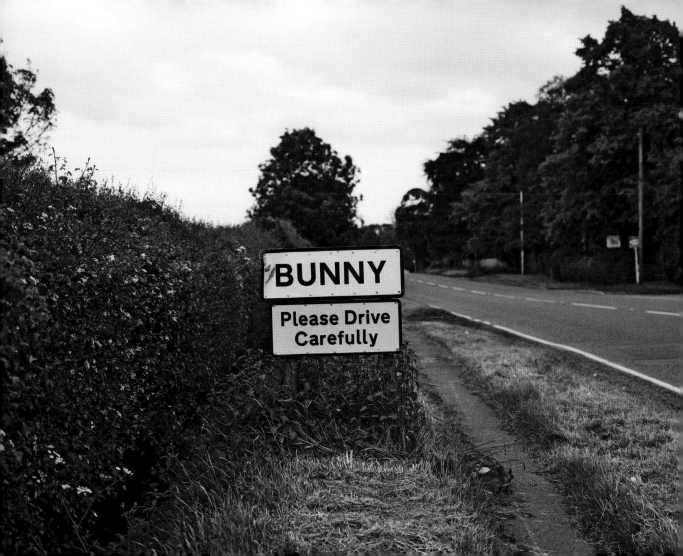

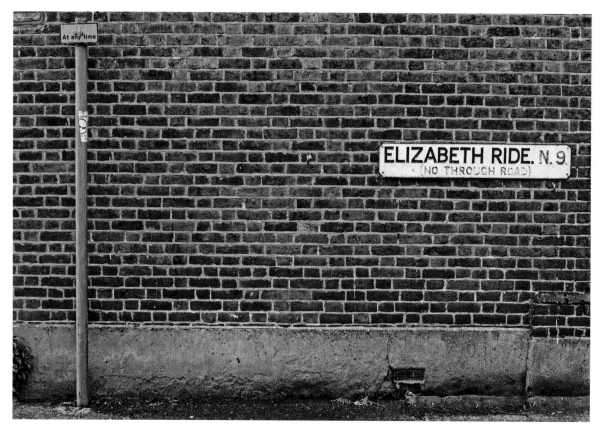

ELIZABETH RIDE ENFIELD, GREATER LONDON, ENGLAND
Etymology *Ride* is possibly 'place suitable for riding', and Elizabeth is likely to be the landowner.
Location Between Tramway Avenue and Tudor Road on the A1010, just down from Ponders End.

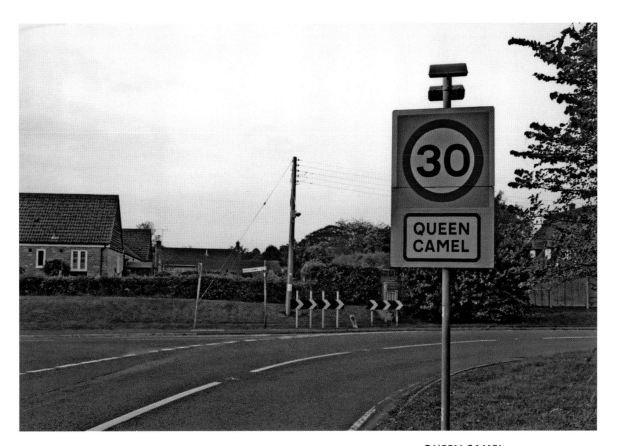

QUEEN CAMEL SOMERSET, ENGLAND
Etymology Owned by Queen Eleanor in the 13th century, Camel might be Celtic 'border hill'; *canto*, 'border' with *mel*, 'bare hill'.
Location Near the sadly unsignposted Heaven's Door, the scarily bizarre Conegore Corner, Wales, Hummer and Compton Pauncefoot. Also on the A359 minutes from the A303.

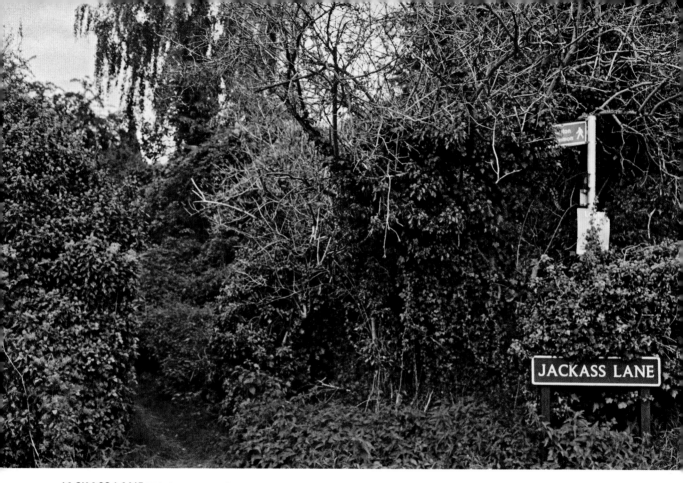

JACKASS LANE KESTON, KENT, ENGLAND
Etymology A jackass is a male adult ass, but also a derogatory name for a stupid person, so there is the likelihood that either one of these was a resident here.
Location Runs between the junctions of Green Gates Rd/Fox Lane and Blackness Rd/Church Rd.

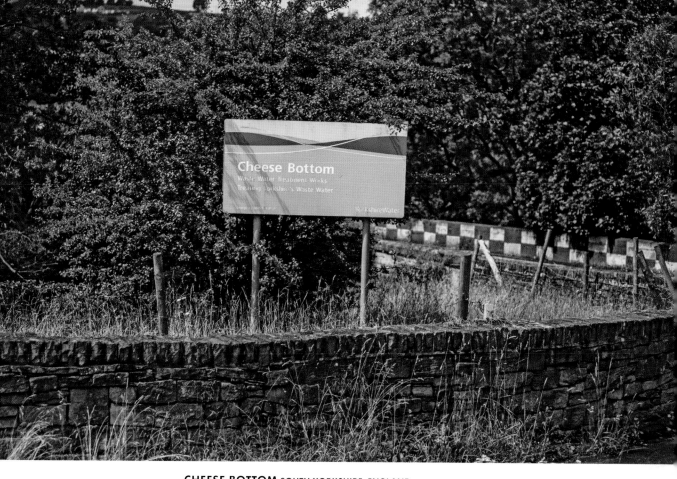

CHEESE BOTTOM SOUTH YORKSHIRE, ENGLAND
Etymology Butter and cheese names usually refer to rich grass for cows, so 'river valley with rich grass'.
Location Head out of Penistone on the B6462 and take a right just after crossing the River Don – if you find yourself on Thurgoland Bank you've gone too far.

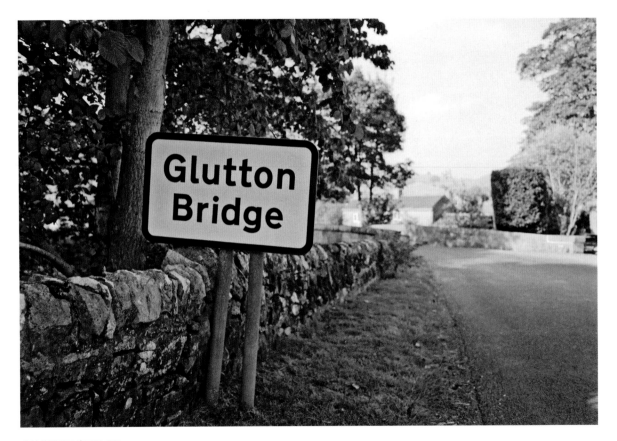

GLUTTON BRIDGE DERBYSHIRE, ENGLAND
Etymology The bridge at a place originally called Glutton House, which seems to be named after a famous big eater.
Location On the B5053, equidistant between Longnor and Brierlow Bar and only five miles from Flash.

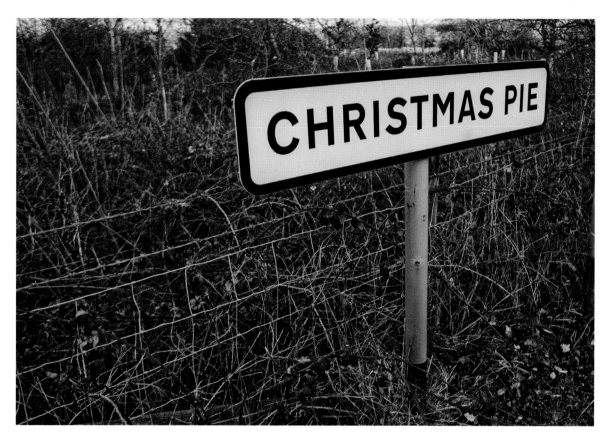

CHRISTMAS PIE SURREY, ENGLAND
Etymology Ironical name; the Christmas family have been known here since the 16th century.
Location A right-hand turn off the Hog's Back road leads you through Wanborough – Christmas Pie is at the junction with Flexford Road.

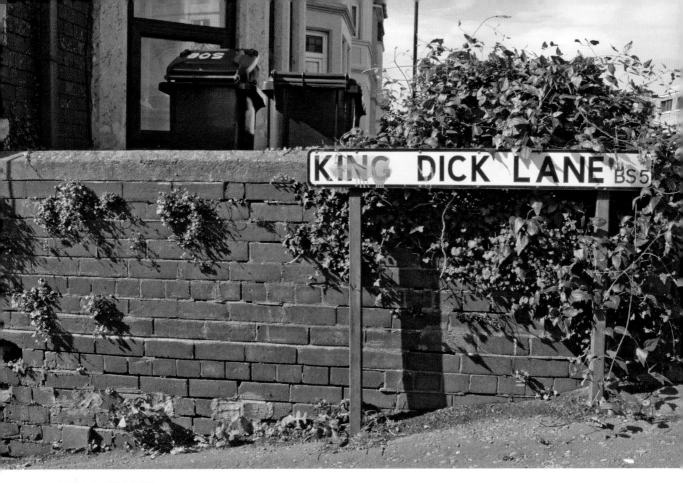

KING DICK LANE ST GEORGE, BRISTOL, ENGLAND
Etymology Possibly a jocular reference to one of the Kings Richard, who might have given his name to a local hostelry.
Location A dead-end lane just off Summer Hill Road.

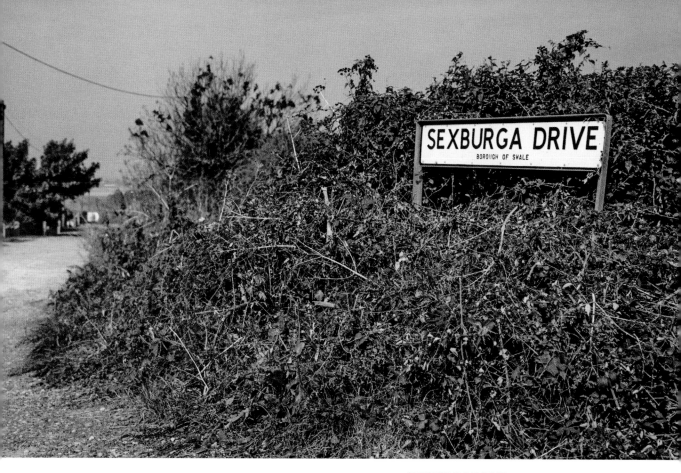

SEXBURGA DRIVE MINSTER, KENT, ENGLAND
Etymology Sexburga was an East Anglian princess who married Eorconberht,
King of Kent. She lived in the later seventh century.
Location An unmade road that runs between Seaside Avenue and The Broadway.

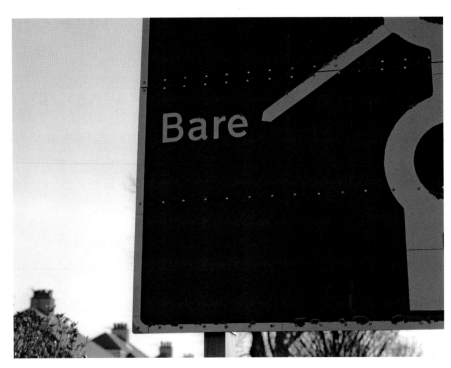

BARE LANCASHIRE, ENGLAND
Etymology Old English *bearu*, 'a grove, a small wood'.
Location On the eastern outskirts of Morecambe near Torrisholme, home to both Happy Mount Drive and Great Wood.

BUTTS VIEW BAKEWELL, DERBYSHIRE, ENGLAND
Etymology This was likely to be the place overlooking the archery butts.
Location In the centre of town, take the B5055 off the A6 – Butts View is just after Butts Road.

BUTTS VIEW

PROGRESS FOUNDRY BURSLEM

PRIVATE ROAD

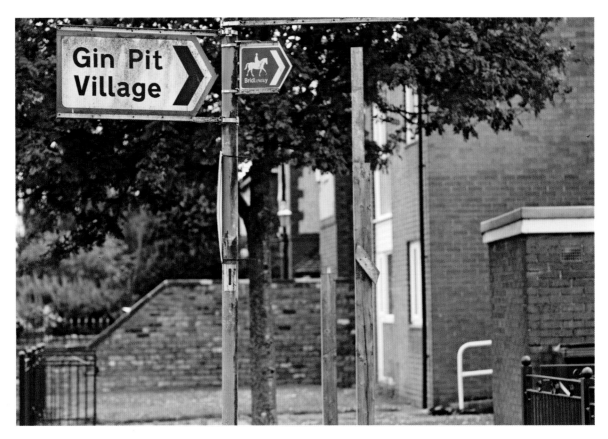

GIN PIT VILLAGE GREATER MANCHESTER, ENGLAND
Etymology A gin pit is one with a mechanical contrivance for doing the work, usually a shallow pit.
Location Entrance into the village is via Peace Street from Meanley Road, opposite the site of the former colliery.

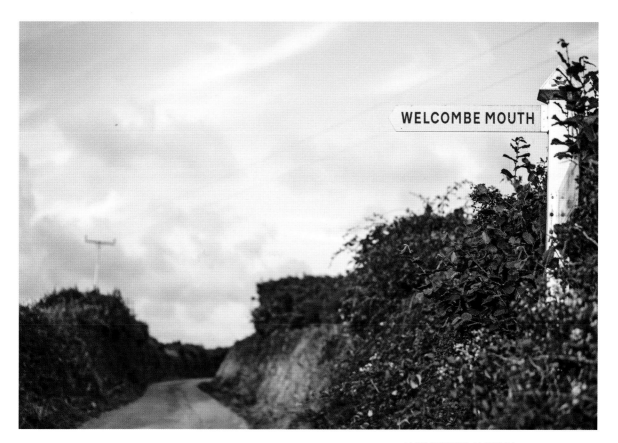

WELCOMBE MOUTH DEVON, ENGLAND
Etymology 'Mouth of the spring in the coomb', Old English *wielle*, 'a spring or stream',
cumb, 'a shallow bowl-shaped valley' and *muða*, '(river) mouth'.
Location Where Strawberry Water reaches the sea below the clifftop hamlet of Welcombe.

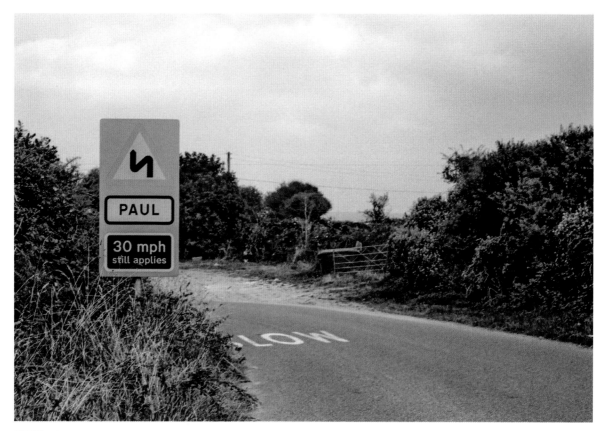

PAUL CORNWALL, ENGLAND
Etymology Named from the church of St Paul or Paulinus, a Welsh saint.
Location Close to Trungle on the Mousehole Lane at the bottom of Boslandew Hill, travelling from Sheffield on the B3315.

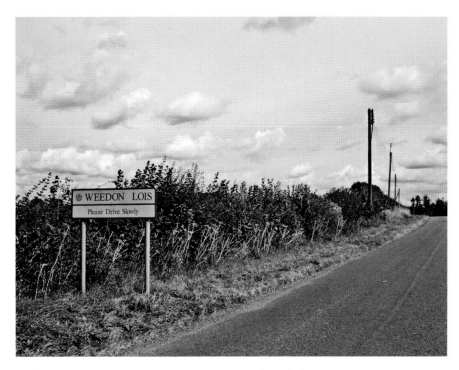

WEEDON LOIS NORTHAMPTONSHIRE, ENGLAND

Etymology An old sacred site on a hill, Old English *weoh*, 'heathen shrine' with *dun*, 'low hill'; Lois is attached to the name from the 15th century, and may refer to St Loys or to a landowner.

Location Near to Moreton Pinkney and Plumpton, home to Lois Weedon Farm.

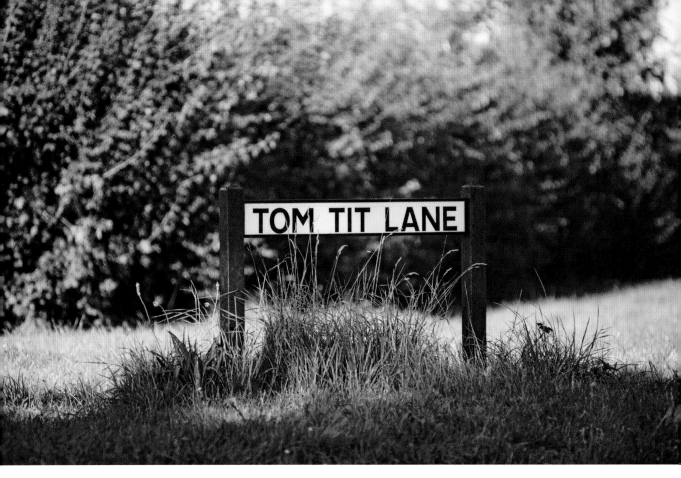

TOM TIT LANE WOODHAM MORTIMER, ESSEX, ENGLAND
Etymology The tomtit is the blue titmouse (blue tit) or coal tit.
Location Runs between Old London Road to the north and the A414 Maldon Road to the south.

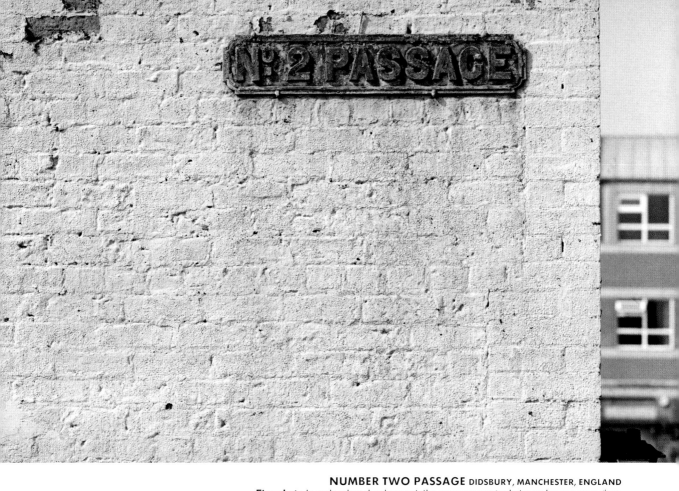

NUMBER TWO PASSAGE DIDSBURY, MANCHESTER, ENGLAND
Etymology In early urban development, the narrow passages between houses were given
distinguishing numbers.
Location Close to the A5145 Wilmslow Road, running between Old Oak Street and Elm Grove.

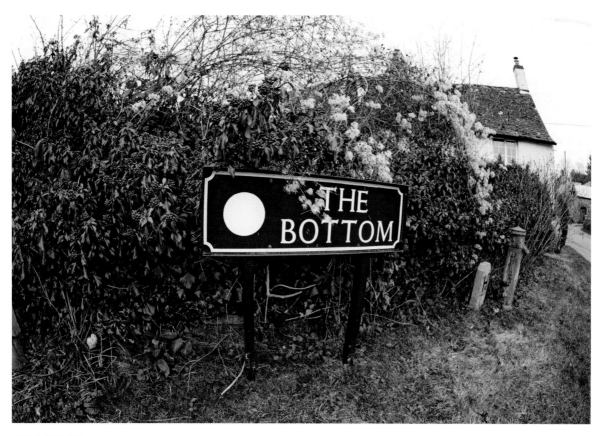

THE BOTTOM FINSTOCK, OXFORDSHIRE, ENGLAND
Etymology Bottom is Old English *bothm*, 'valley bottom'.
Location At the junction of Well Hill and Wilcote Riding.

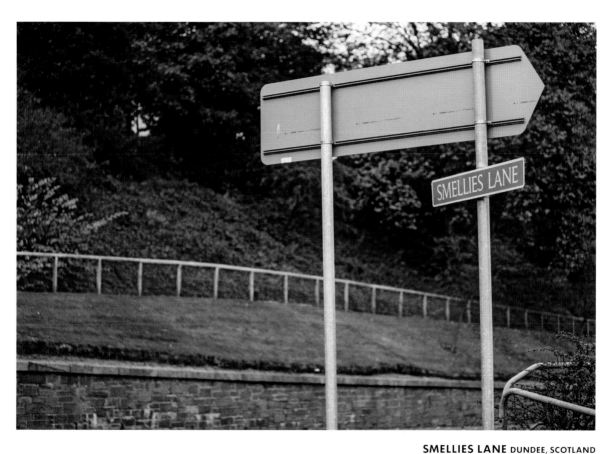

SMELLIES LANE DUNDEE, SCOTLAND
Etymology Smellie is a common Scottish surname.
Location Opposite the brilliantly named Dudhope Park, running between Lochee Road and Ash Street.

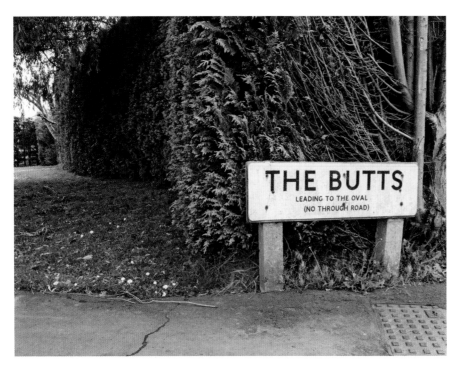

THE BUTTS BROXBOURNE, HERTFORDSHIRE, ENGLAND
Etymology A *butt* in Middle English is either an irregular piece of land at the end of arable strips, or a place for practising archery.
Location Running between the A1170 and The Oval near the New River.

SCATNESS SHETLAND, SCOTLAND
Etymology The second element is Old Norse *nes*, 'a headland'. The first element may be *skat*, 'rent or payment', so possibly 'headland on which rent was payable'.
Location The western perimeter of Sumburgh Airport on the A970.

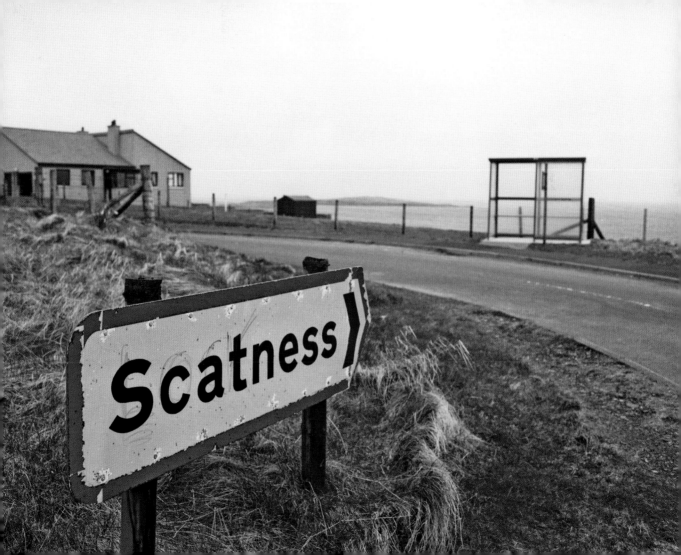

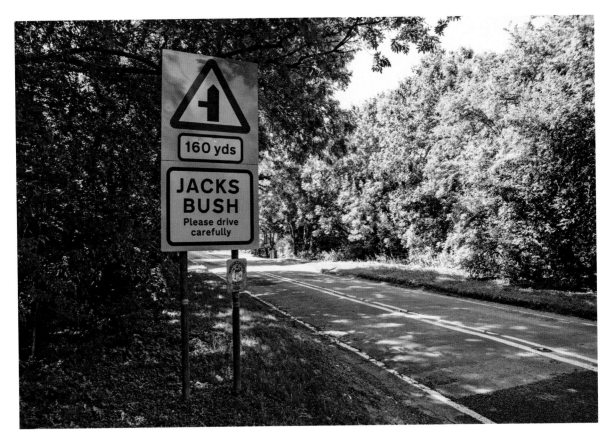

JACKS BUSH HAMPSHIRE, ENGLAND
Etymology *Jack* is a name given to vacant or unused land, so 'unused land growing with bushes'.
Location Just down the A343 from Over Wallop, near to Martin's Clump.

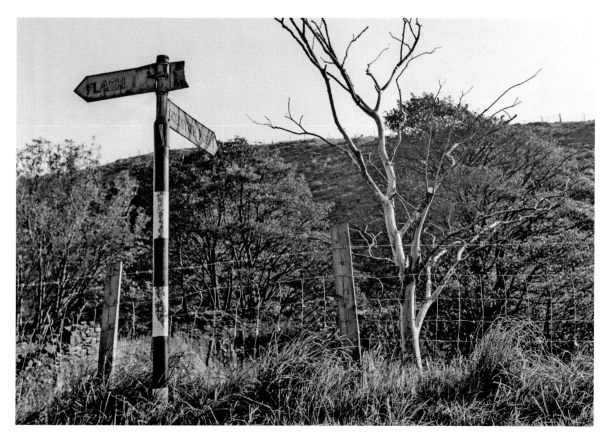

FLASH STAFFORDSHIRE, ENGLAND
Etymology From the Middle English *flasshe*, meaning 'swamp'.
Location Just off the A53 and up the hill from the one that got away –the unsignposted Flash Bottom.

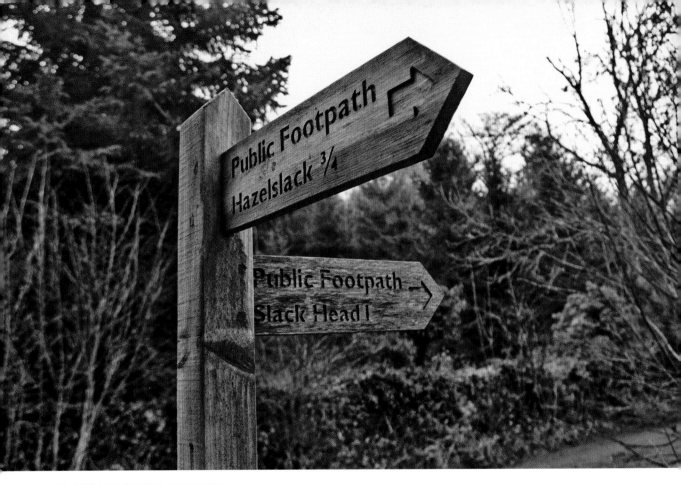

SLACK HEAD CUMBRIA, ENGLAND
Etymology A *slack*, from Old Norse *slakki*, is 'land in a shallow valley, a hollow'; this place is at the head of the valley.
Location Found in Beetham between Major Woods and Fieryhouse Wood.

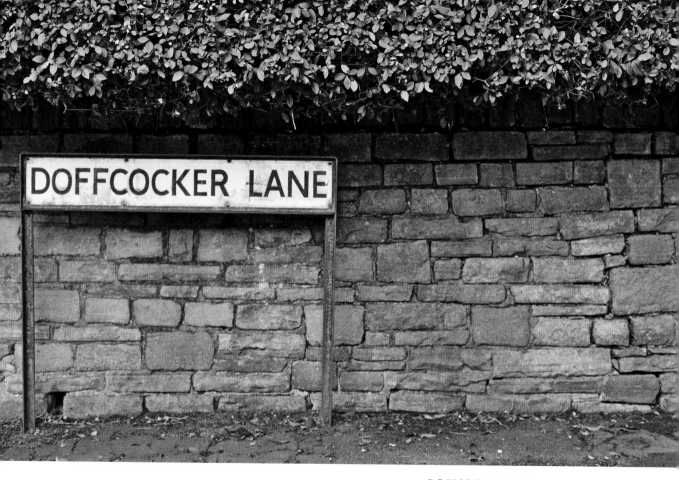

DOFFCOCKER LANE BOLTON, ENGLAND
Etymology This may be made up of *doff*, 'take off' and *cockers*, 'boots, leggings',
and may refer to a dry passage on the lane.
Location Take the turning off the B6226 Chorley Old Road at the Doffcocker Inn.

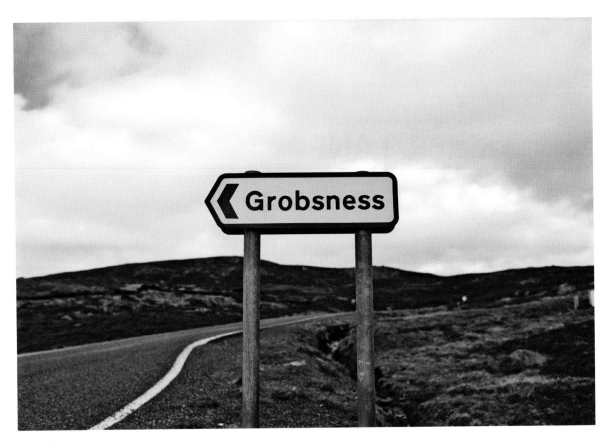

GROBSNESS SHETLAND, SCOTLAND
Etymology Old Norse *nes*, 'a headland', is the second element.
Location Off the B9071 on Mainland (the main island of Shetland). It leads to Grobsness Haa,
an abandoned 18th-century house, typically two-storey and gable-ended.

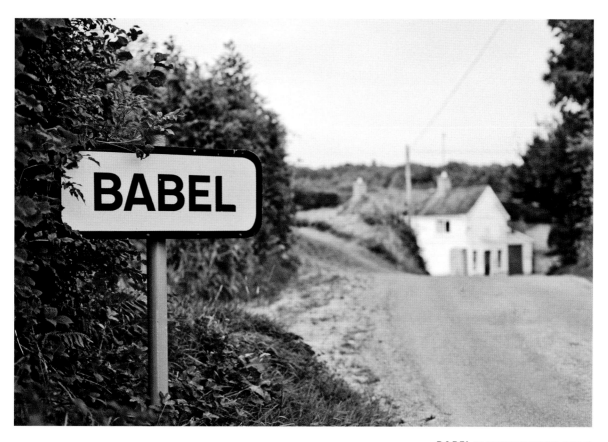

BABEL CARMARTHENSHIRE, WALES
Etymology A biblical chapel name, if rather a puzzling one, since the Tower of Babel was an idolatrous monument.
Location Two miles from the A40, equidistant between Mwmffri and Halfway Forest, near the border with Powys.

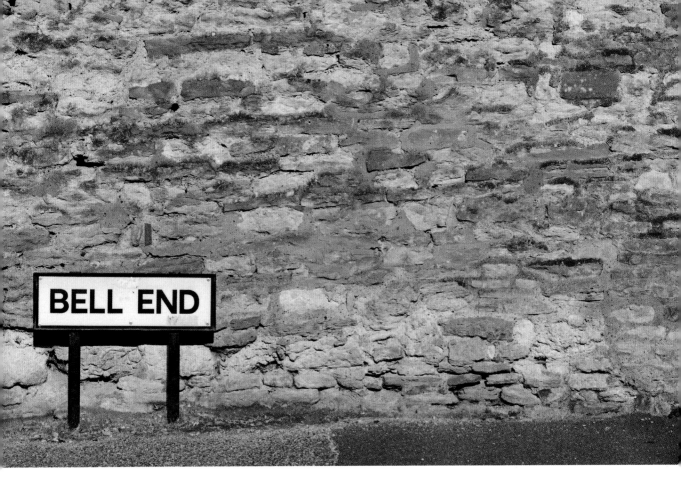

BELL END WOLLASTON, NORTHAMPTONSHIRE, ENGLAND
Etymology 'End' means 'district', Bell is probably either a surname or a reference to a piece of land endowed for maintenance of the church bells.
Location Runs between the B569 and the High Street, a stone's throw from the Dr Martens factory.

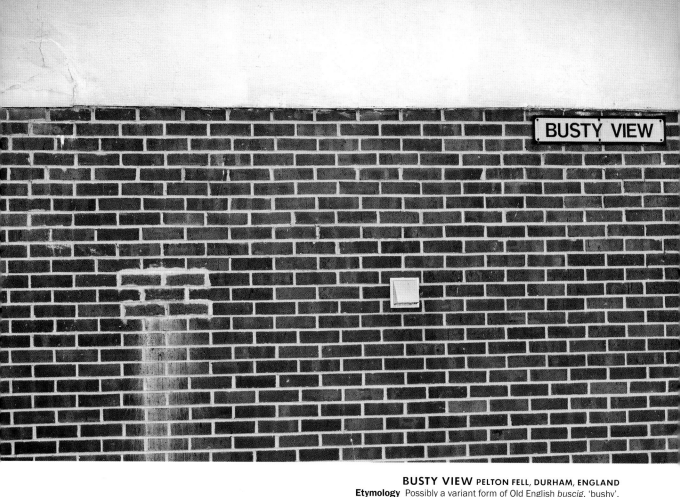

BUSTY VIEW PELTON FELL, DURHAM, ENGLAND
Etymology Possibly a variant form of Old English *buscig*, 'bushy'.
Location Leave Chester-le-Street on the B6313 and take a right-hand turn for Newfield.

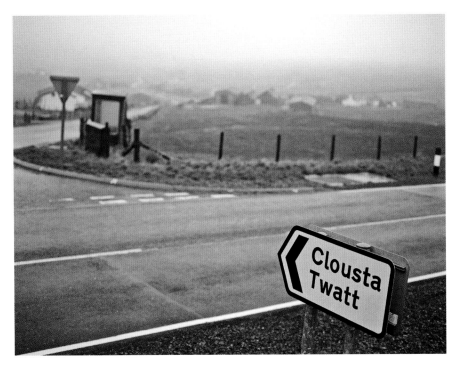

TWATT SHETLAND, SCOTLAND
Etymology From the Old Norse Þveit, 'cleared land'.
Location Take the A971 from Tingwall and turn right just after Bixter onto the B9071; soon after you will see the sign for Clousta and Twatt pointing left.

TWITTY FEE DANBURY, ESSEX, ENGLAND
Etymology The Twitty family is known here from the 16th century; if the name is older than that, the Fee may refer to land for cattle to graze, if not, then to the rental of the land.
Location A dead-end lane at the end of Hopping Jacks Lane.

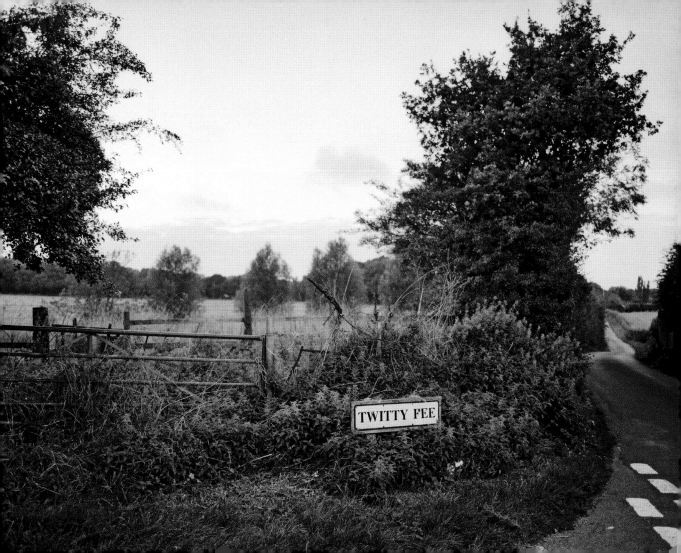

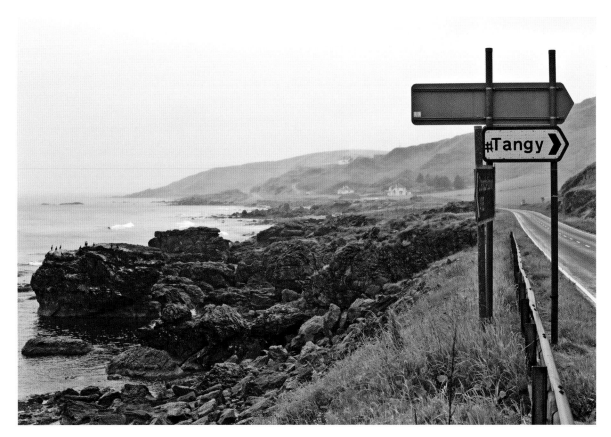

TANGY ARGYLL & BUTE, SCOTLAND
Etymology Possibly Scandinavian *tunga*, 'a tongue of land'.
Location Turn off the A83 halfway between Glenbarr and Campbeltown. Tangy is the farm on the southern bank of Tangy Burn below Tangy Loch, which has the remains of a fortified dwelling. Not too far from Breakachy.

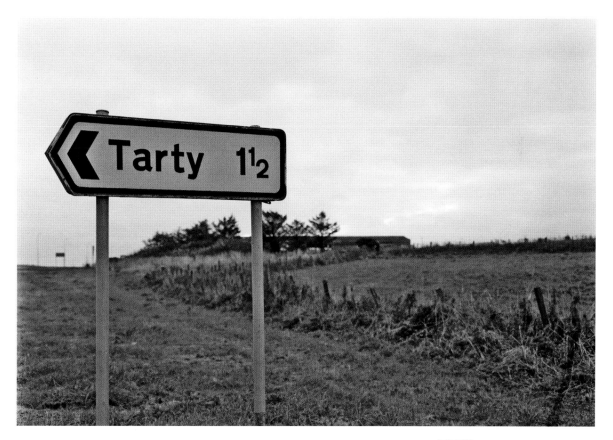

TARTY ABERDEENSHIRE, SCOTLAND
Etymology Unknown.
Location Turn off the A90 near Tipperty. On its way to Meikle Tarty (to give it its full name), the road crosses Tarty Burn which is a tributary of Ythan River, the estuary of which is a Site of Special Scientific Interest on account of the Sandwich Terns who just love nesting here.

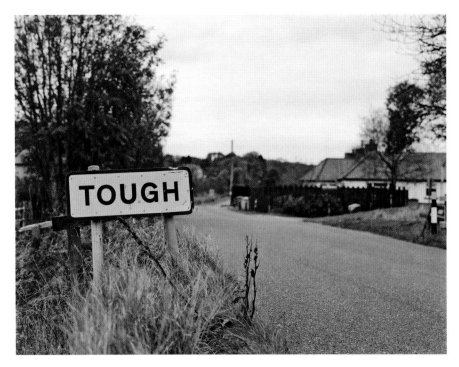

TOUGH ABERDEENSHIRE, SCOTLAND
Etymology Probably 'hill', from Gaelic *tulach*.
Location Just off the A944, equidistant between Comers and Tarlands, not too far from the Peel Ring of Lumphanan.

TITTY HO RAUNDS, NORTHAMPTONSHIRE, ENGLAND
Etymology Possibly a reference to the common bird, the tit.
Location Runs parallel to Hog Dyke between the B663 and London Road.

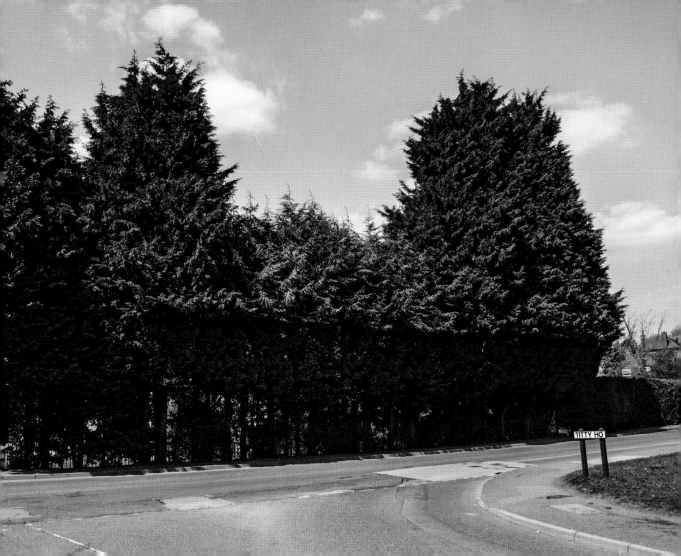

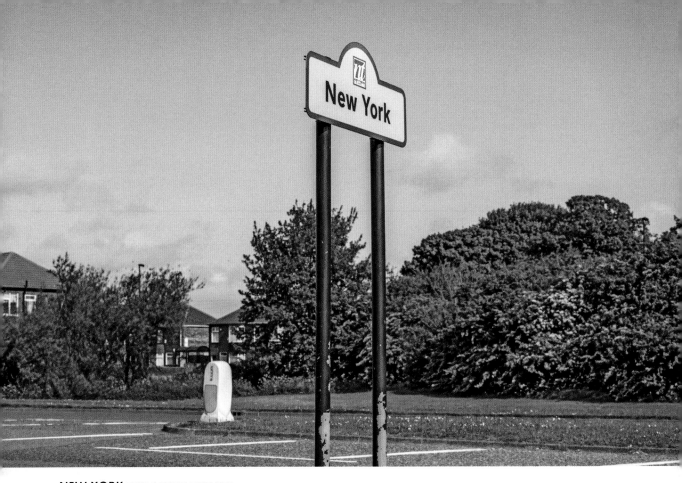

NEW YORK TYNE & WEAR, ENGLAND
Etymology Probably a transferred name from either York (to the south) or New York, USA.
Location A small community divided from Murton by the A191.

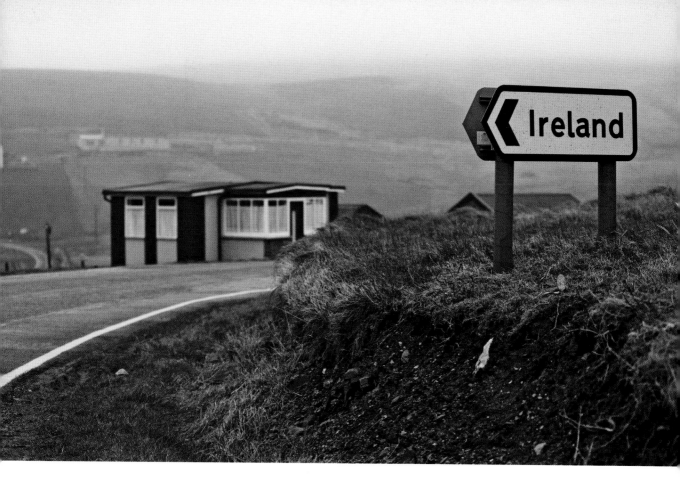

IRELAND SHETLAND, SCOTLAND
Etymology From the Old Norse *eyrr*, meaning beach or spit.
Location If coming from the north on the B9122, turn right just after crossing the
Burn of Sevdale and right again at the Bigton Store, which will lead you to Ireland.

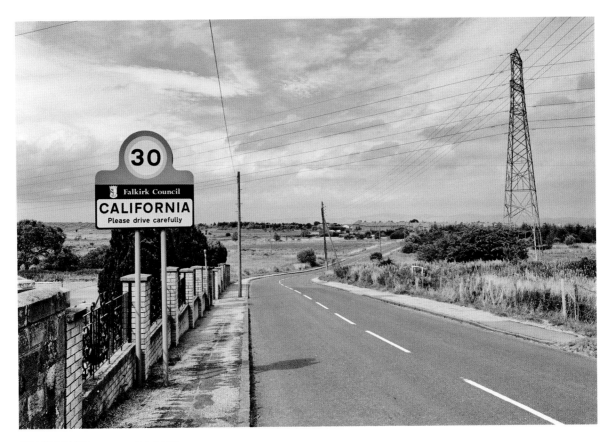

CALIFORNIA FALKIRK, SCOTLAND
Etymology A name transferred from the USA, signifying a remote place.
Location On the B8028 south of Shieldhill, only five miles from Easter Fannyside.

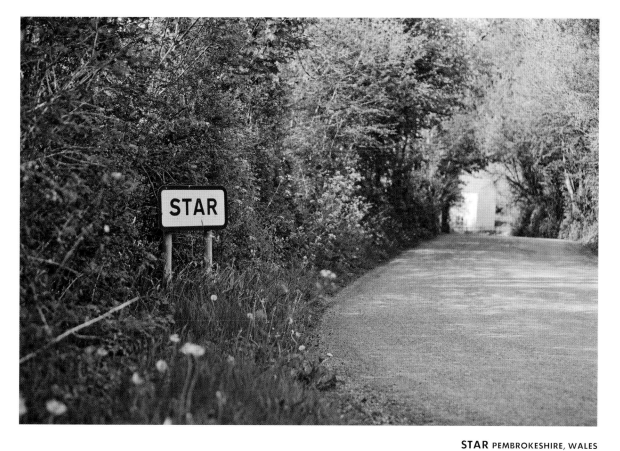

STAR PEMBROKESHIRE, WALES
Etymology Named after the Star Inn, recorded 1823.
Location About 5 miles east of the A478 between Clydey and Tegryn.

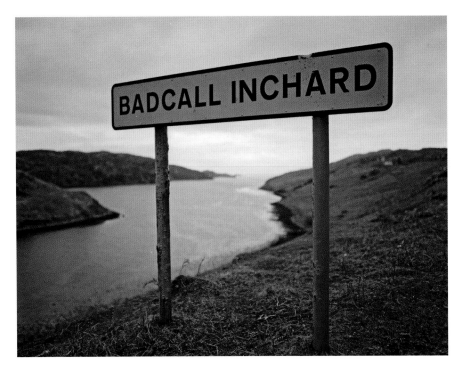

BADCALL INCHARD SUTHERLAND, SCOTLAND
Etymology Badcall is 'hazel grove', this one near Loch Inchard, probably 'meadow fjord'.
Location Turn off the A838 at Richonich – Badcall is on the northern side of Loch Inchard,
a couple of miles along the B801.

CRONK Y VODDY KIRK-GERMAN PARISH, ISLE OF MAN
Etymology 'Hill of the old man', Manx Gaelic *cnoc a'bhodaich*.
Location At the crossroads of Ballabooie Road, the A3 and Little London Road, only a mile and a half
from Rhenass River.

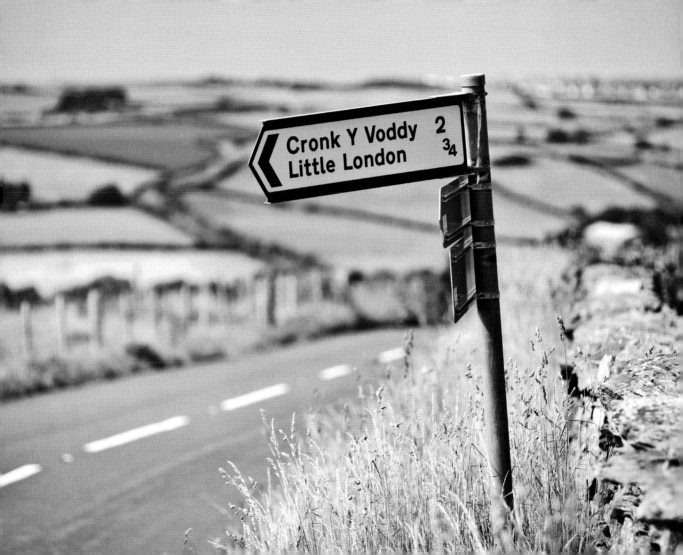

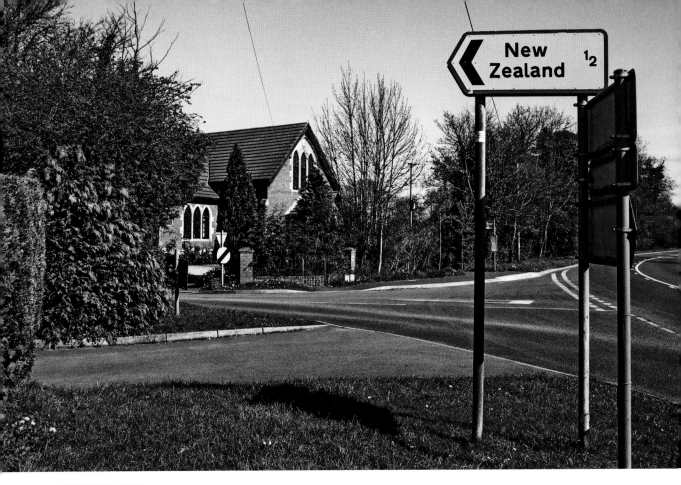

NEW ZEALAND WILTSHIRE, ENGLAND
Etymology A transferred name signifying a remote place.
Location A hamlet on the edge of RAF Lyneham, not too far from Sodom.

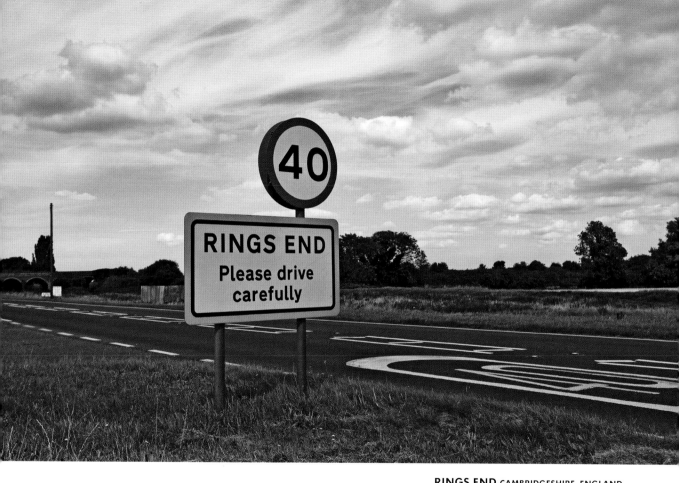

RINGS END CAMBRIDGESHIRE, ENGLAND

Etymology The Ring was a roughly circular bank used in the process of draining the fenlands here; the end refers to one of the terminations of the ring.

Location Head north out of March on the A141 – the village is at the junction with the A47.

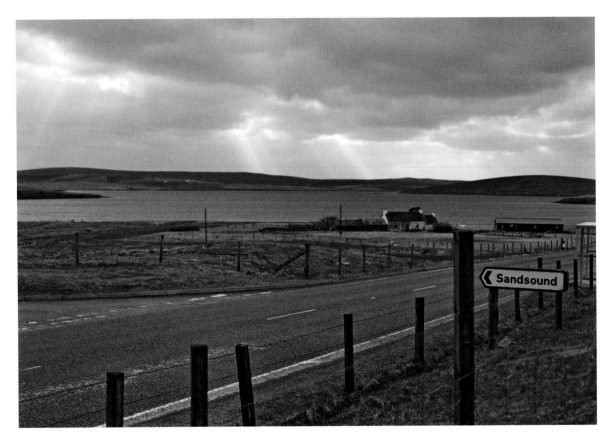

SANDSOUND SHETLAND, SCOTLAND
Etymology From Old Norse 'sandy inlet'.
Location Overlooking Sandsound Voe off the A971 at Tresta, four miles from Twatt.

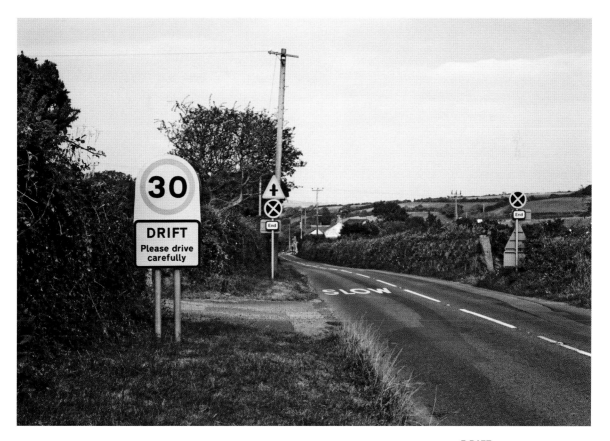

DRIFT CORNWALL, ENGLAND
Etymology Cornish *an dref*, 'the village'.
Location Equidistant between Grumbla and Paul on the A30 and home to the Drift Stones, otherwise known as the Triganeeris Sisters, a pair of two-metre-high standing stones.

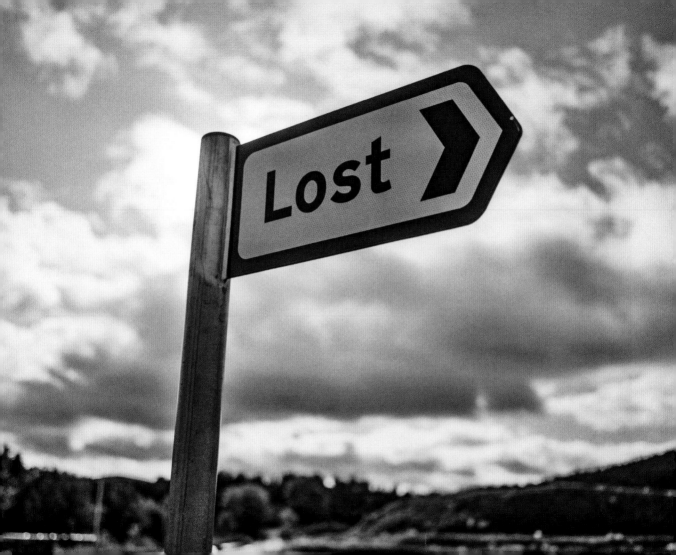

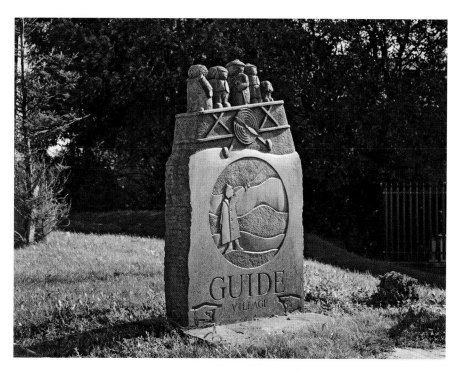

LOST ABERDEENSHIRE, SCOTLAND
Etymology Likely for Gaelic *loisid*, 'a kneading trough', quite commonly used for good agricultural land.
Location A quiet turning off the A944 at Bellabeg, just over 10 miles from Balmoral; home to The Lost Gallery.

GUIDE LANCASHIRE, ENGLAND
Etymology *Guide* sometimes refers to a signpost, so possibly 'place with a signpost'.
Location Sandwiched between the B6322 Haslingden Road and the M65 Calder Valley Motorway.

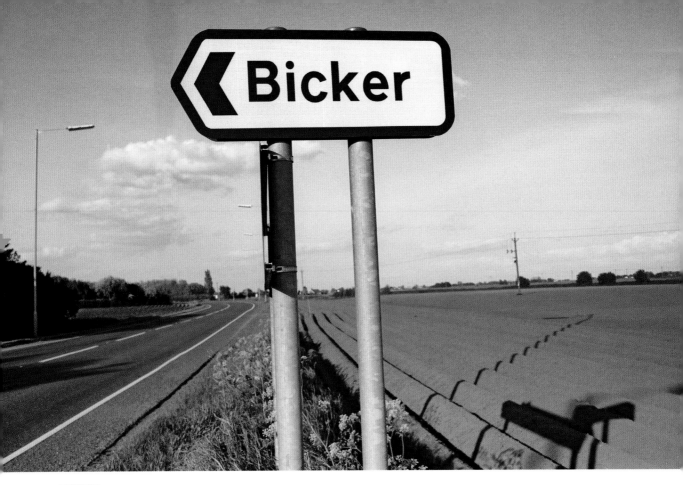

BICKER LINCOLNSHIRE, ENGLAND
Etymology Old English *bi*, '(land) beside', with Scandinavian *kjarr*, 'marsh'.
Location On the A52 between Bicker Bar and Donington Eaudike.

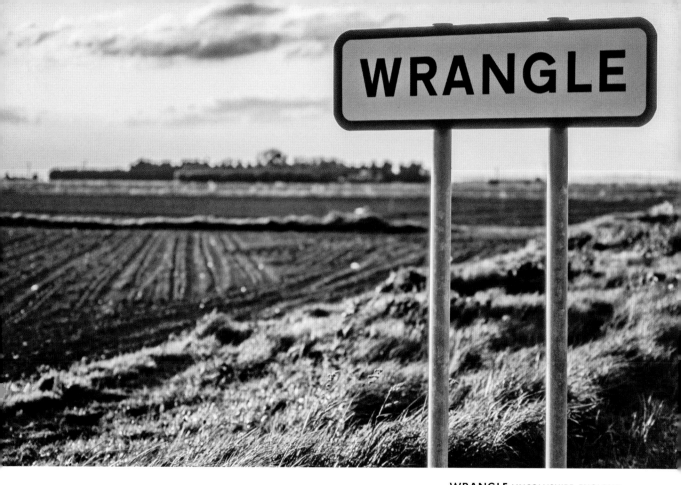

WRANGLE LINCOLNSHIRE, ENGLAND
Etymology From Old English *wrangel*, 'a crooked place', so by a bend in a road, valley or river.
Location On the A52, just north of Old Leake.

BENT LANE BROWNLOW, CHESHIRE
Etymology This could be *bent* in the sense 'twisty', or could refer to bent grass,
a rank grass unsuitable for cattle.
Location An unassuming turning off the A34 between Peel Lane and Fol Hollow.

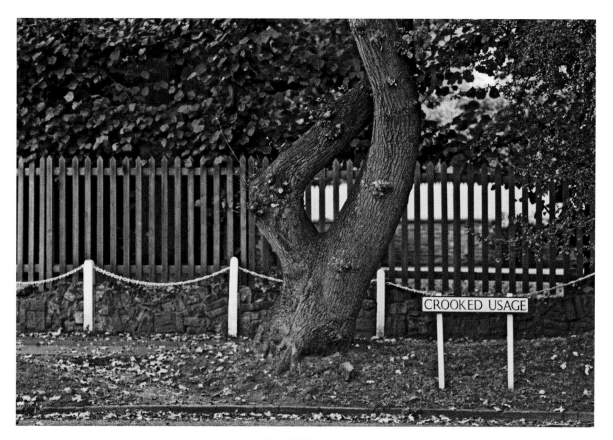

CROOKED USAGE FINCHLEY CHURCH END, GREATER LONDON, ENGLAND
Etymology Possibly a reference to an old dispute, but it may be an ironical name for a twisty lane.
Location A dogleg of a road with both ends on Hendon Lane near the Great North Way, also known as the A1.

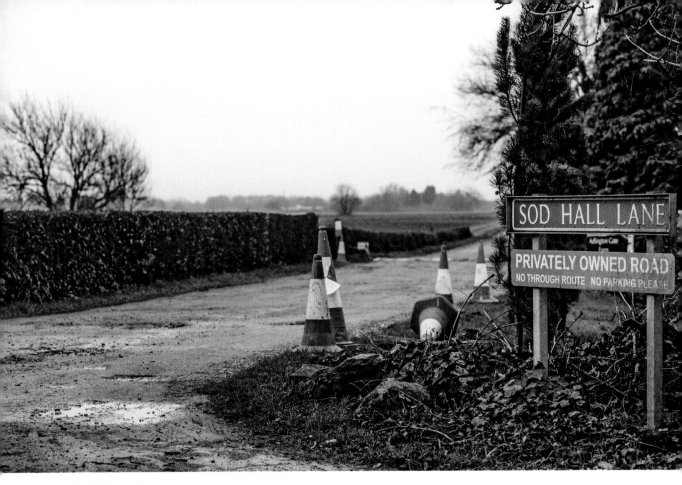

SOD HALL LANE NEW LONGTON, LANCASHIRE, ENGLAND
Etymology After a long-disappeared wattle-and-daub house – most probably named ironically.
Location A track running between Longmeanygate and Long Moss Lane, near Leyland.

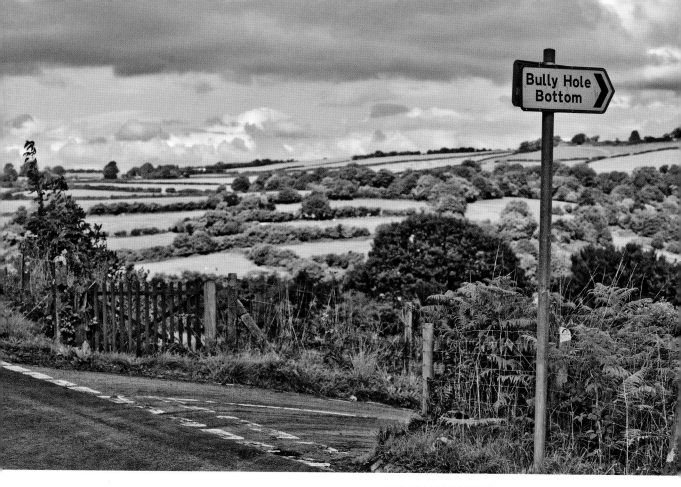

BULLY HOLE BOTTOM MONMOUTHSHIRE, WALES

Etymology *Hole* is 'hollow', and *bottom* 'shallow river valley'; so this might be where bulls grazed in a water-meadow, a nook in a valley. But it might be possible that *Bully* is an English version of a Welsh word for a pool.
Location Just off the B4235 on the road to Kilgwrrwg Common.

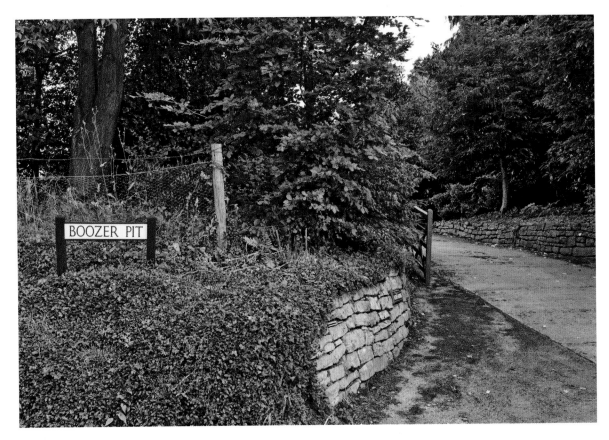

BOOZER PIT MERRIOT, SOMERSET, ENGLAND
Etymology Possibly 'pit by cowstalls'.
Location If driving from Chiselborough on the A356, take the right turn on the second dogleg.

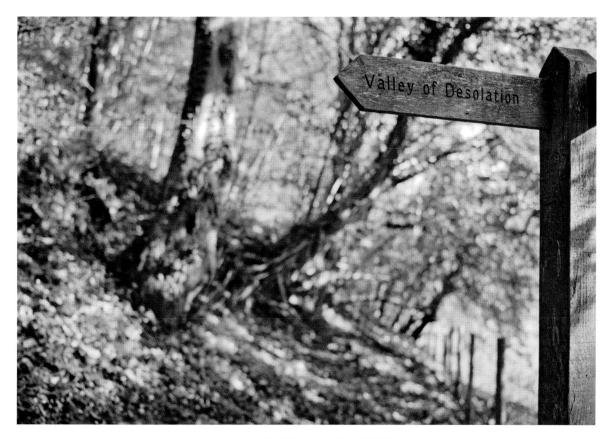

VALLEY OF DESOLATION BOLTON ABBEY, NORTH YORKSHIRE, ENGLAND
Etymology A beautiful valley that was devastated by a storm in 1826.
Location On the path to the 1500ft high Simon's Seat and a 20 minute walk from the River Wharfe on the Bolton Abbey estate.

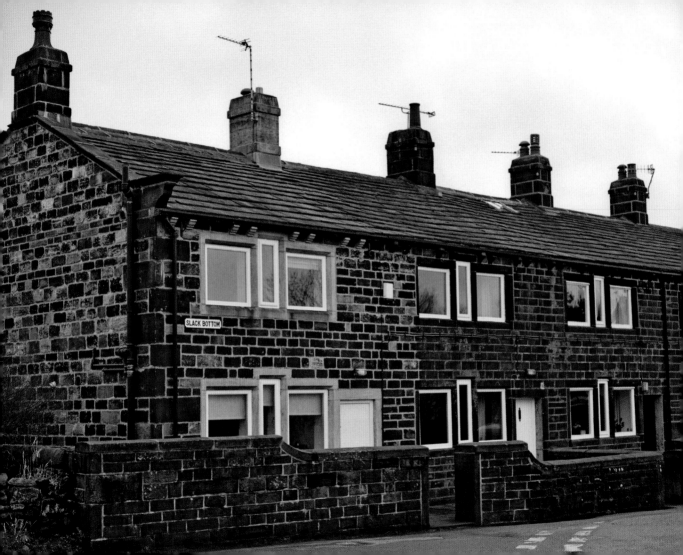

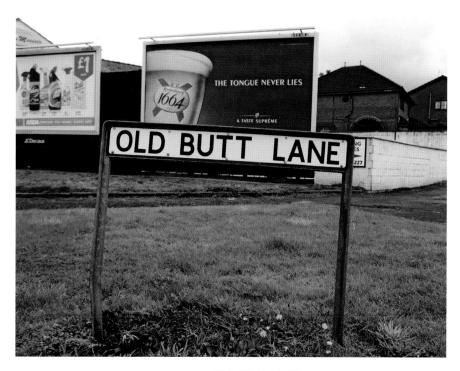

OLD BUTT LANE TALKE, STAFFORDSHIRE, ENGLAND
Etymology Probably a reference to a lane passing an irregular piece of land (a *butt*); the 'old' may refer to the possibility that the land has since been lost as a distinct plot.
Location Head north along the A34 past the Ebeneezer Gospel Hall, and turn left opposite Slacken Lane, on the border of Cheshire and Staffordshire.

SLACK BOTTOM WEST YORKSHIRE, ENGLAND
Etymology Scandinavian *slakki*, 'a hollow, small valley', Old English *bothm*, 'valley bottom' although it is possible that this was coined recently with a view to humour.
Location Head off the A646 through Heptonstall and it's not too far from Midgehole and Colden.

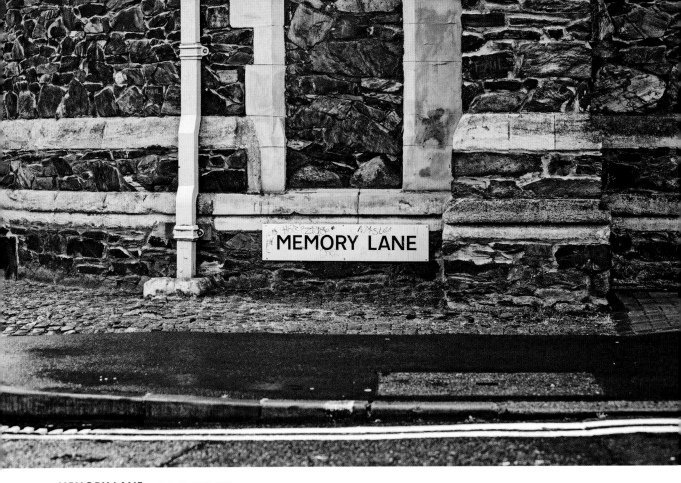

MEMORY LANE LEICESTER, ENGLAND

Etymology Probably a sentimental name; the lane is near Leicester College, and may thus affectionately refer to 'salad days' at school.

Location A dead end off the A607 Belgrave Gate.

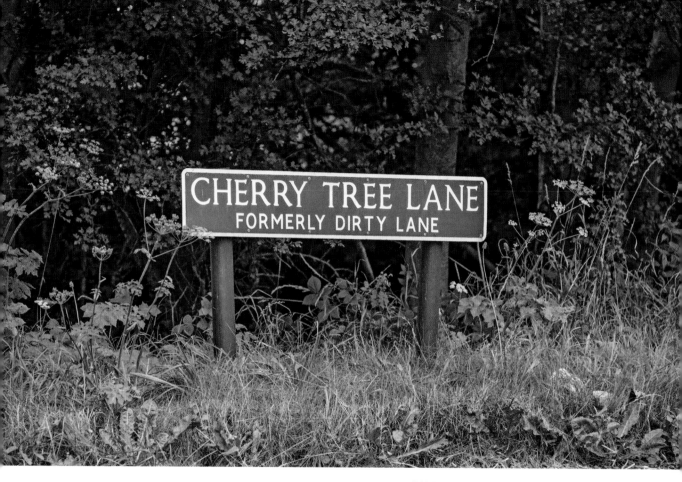

DIRTY LANE ROSTHERNE, CHESHIRE, ENGLAND
Etymology From Old English *drit*, 'dirt, mud'.
Location This lane takes you from the A556 to Rostherne.

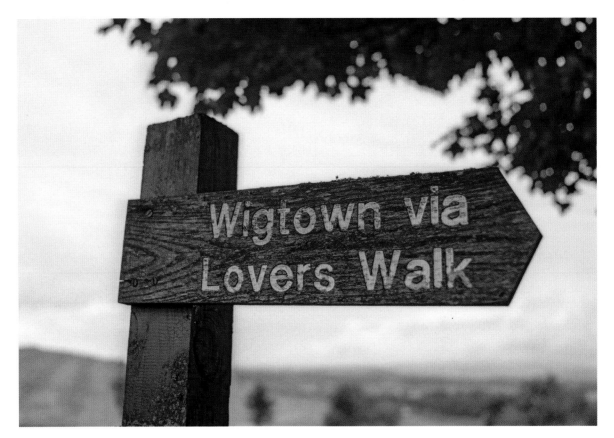

WIGTOWN via LOVERS WALK DUMFRIES, SCOTLAND
Etymology Probably 'farm with a depot', Old English *wic*, 'depot', with *tun*, 'a farm, estate, village'.
'Lovers' Walk' is a name given to usually remote places used by amorous couples.
Location Scotland's National Book Town, Wigtown is on the A714 near the River Bladnoch.

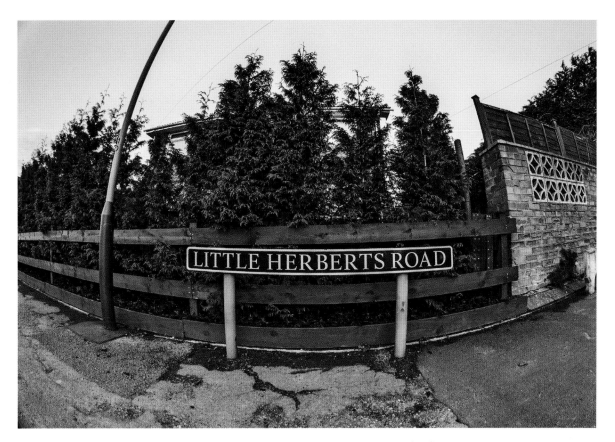

LITTLE HERBERTS ROAD CHELTENHAM, GLOUCESTERSHIRE
Etymology A landowner in the area called Herbert is known in the 15th century; this was an outlying area of his estate.
Location A suburban road leading into Horsefair Street from Timbercombe Lane.

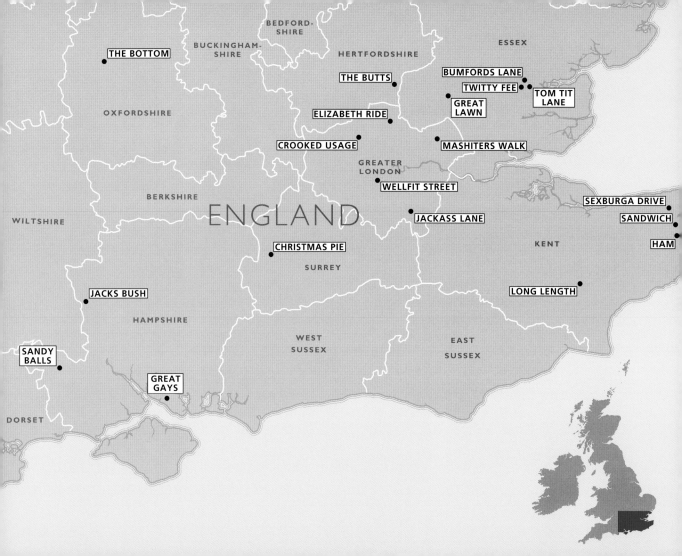

THE BOTTOM

BUCKINGHAM-
SHIRE

BEDFORD-
SHIRE

HERTFORDSHIRE

ESSEX

THE BUTTS

BUMFORDS LANE

TWITTY FEE

TOM TIT
LANE

OXFORDSHIRE

GREAT
LAWN

ELIZABETH RIDE

CROOKED USAGE

MASHITERS WALK

GREATER
LONDON

BERKSHIRE

WELLFIT STREET

SEXBURGA DRIVE

ENGLAND

JACKASS LANE

SANDWICH

WILTSHIRE

HAM

KENT

CHRISTMAS PIE

SURREY

JACKS BUSH

LONG LENGTH

HAMPSHIRE

WEST
SUSSEX

EAST
SUSSEX

SANDY
BALLS

GREAT
GAYS

DORSET

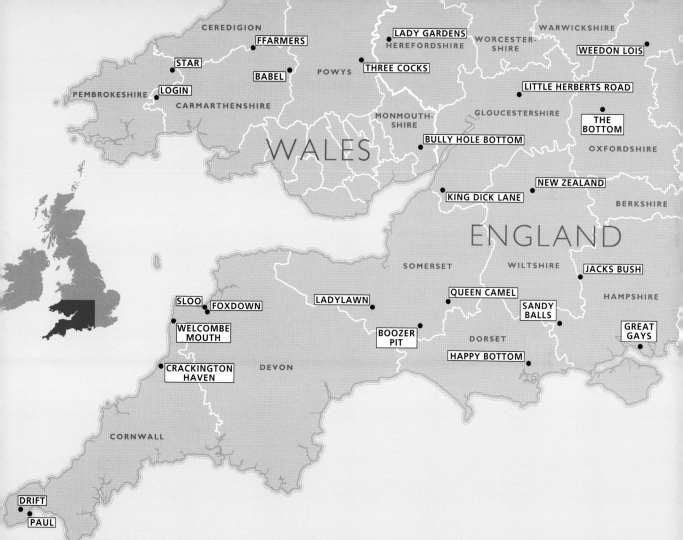

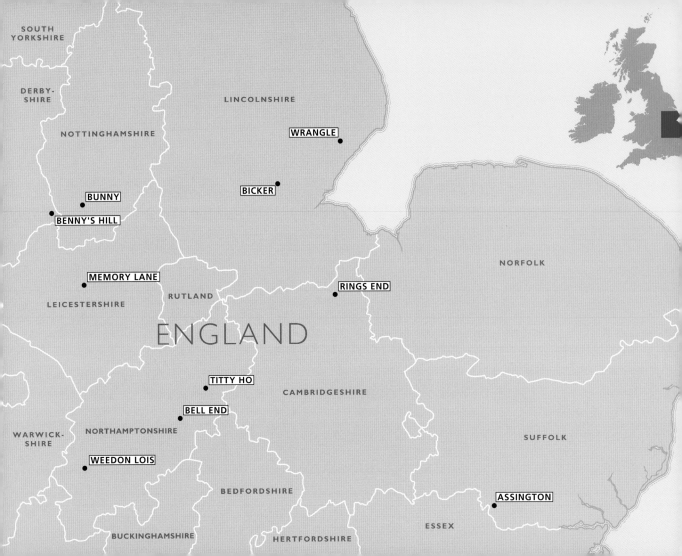

SOUTH
YORKSHIRE

DERBY-
SHIRE

NOTTINGHAMSHIRE

LINCOLNSHIRE

WRANGLE

BICKER

BUNNY

BENNY'S HILL

MEMORY LANE

NORFOLK

LEICESTERSHIRE

RUTLAND

RINGS END

ENGLAND

TITTY HO

CAMBRIDGESHIRE

BELL END

SUFFOLK

NORTHAMPTONSHIRE

WARWICK-
SHIRE

WEEDON LOIS

BEDFORDSHIRE

ASSINGTON

BUCKINGHAMSHIRE

HERTFORDSHIRE

ESSEX

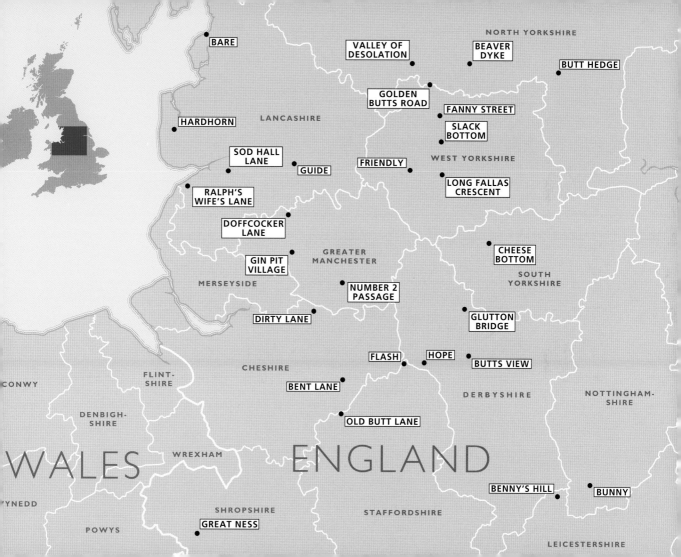

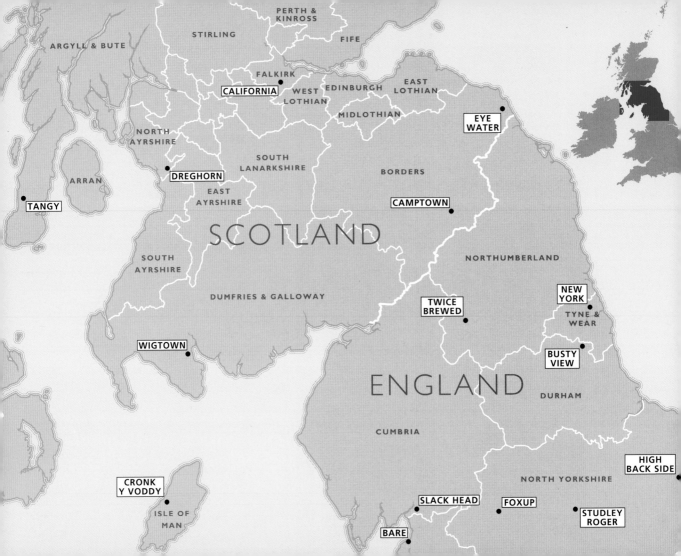

ARGYLL & BUTE

STIRLING

PERTH & KINROSS

FIFE

FALKIRK

CALIFORNIA

WEST LOTHIAN

EDINBURGH

EAST LOTHIAN

MIDLOTHIAN

EYE WATER

NORTH AYRSHIRE

ARRAN

DREGHORN

SOUTH LANARKSHIRE

BORDERS

TANGY

EAST AYRSHIRE

CAMPTOWN

SCOTLAND

SOUTH AYRSHIRE

NORTHUMBERLAND

DUMFRIES & GALLOWAY

TWICE BREWED

NEW YORK

TYNE & WEAR

WIGTOWN

BUSTY VIEW

ENGLAND

DURHAM

CUMBRIA

HIGH BACK SIDE

CRONK Y VODDY

NORTH YORKSHIRE

SLACK HEAD

FOXUP

STUDLEY ROGER

ISLE OF MAN

BARE

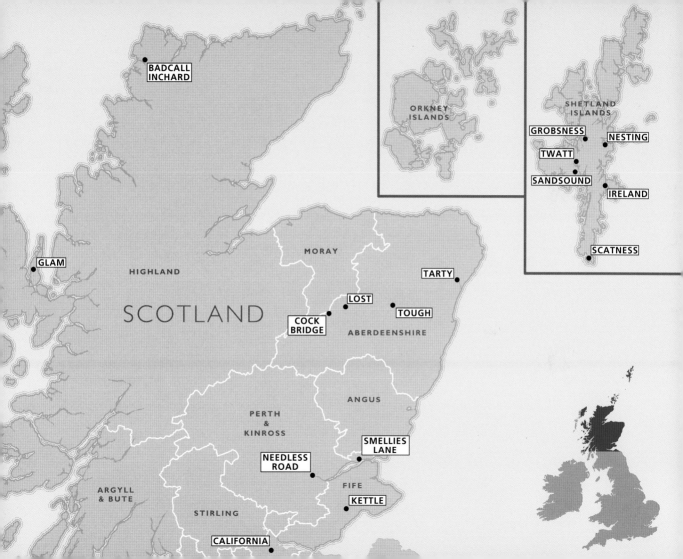

SCOTLAND

BADCALL INCHARD

GLAM

HIGHLAND

MORAY

LOST

COCK BRIDGE

TARTY

TOUGH

ABERDEENSHIRE

ANGUS

PERTH & KINROSS

SMELLIES LANE

NEEDLESS ROAD

FIFE

KETTLE

ARGYLL & BUTE

STIRLING

CALIFORNIA

ORKNEY ISLANDS

SHETLAND ISLANDS

GROBSNESS

NESTING

TWATT

SANDSOUND

IRELAND

SCATNESS

Dedicated to my two boys George and Daniel - you won't be allowed to read the book just yet!

Also dedicated to Alison - thanks for the love and support and holding the fort.

A big thank you to Dominic Beddow for the maps and to Dr Paul Cavill of the English Place-Name Society who compiled the etymologies. Thanks also to Polly Powell for spotting my work in a sea of products at a trade show and Nicola Newman for expert editing.

Thanks also to Tania Freckleface Lambert for pointing me towards Boozer Pit, Niamh Gillespie for Wellfit Street and Emma Beaumont for Long Fallas Crescent. And not forgetting the sterling efforts of eminent Lancashologist Ted Champion (aka Chris Winters) in locating the last remaining signpost for Hardhorn.

This book is the latest instalment in a project that began in 2002 with a TV series, *Lesser Spotted Britain*, on Channel 4 followed by a bestselling book, 2004's *Far From Dull and Other Places*. In 2008 a range of greeting cards, mugs, coasters and other gifts was launched, with the intention of educating and offending in a single product. These continue to pique the interest of people the world over.

If you like this book please visit

www.lesserspotted.com

to see the full range of Great British place-name products.